Louisville DINERS

Evan & Hannah,
 Congratulations on your upcoming
marriage. Happy eating!!

[signature: Ashlee Clark Thompson]

ASHLEE CLARK THOMPSON

AMERICAN PALATE

Published by American Palate
A Division of The History Press
Charleston, SC 29403
www.historypress.net

Copyright © 2015 by Ashlee Clark Thompson
All rights reserved

First published 2015

Manufactured in the United States

ISBN 978.1.62619.897.5

Library of Congress Control Number: 2014954494

Notice: The information in this book is true and complete to the best of our knowledge. It is offered without guarantee on the part of the author or The History Press. The author and The History Press disclaim all liability in connection with the use of this book.

For Rob,
Budapest.
Love, Ashlee

CONTENTS

CONTENTS

NOTE TO READERS

C all ahead and/or look online if you want to visit one of the diners that I've profiled in this book. The restaurant industry can be tough, so you'll want to confirm that a location is still open before you arrive. Also confirm hours of operation, menus and prices, all of which might have changed since the publication of this book.

This book is a snapshot of the diverse diner scene that Louisville offers. This is by no means an exhaustive list of all the diners in Louisville. I encourage you to use this book as a guide to begin your own diner adventures. Have fun, and happy eating.

PREFACE

Louisville diners are powerful little businesses. With straightforward menus and no-frills service, these establishments encourage us to embrace the simple, satisfying pleasures in life. We applaud meatloaf that holds its own against the Sunday dinners of our childhoods or peach cobbler that could rival any dessert at a church picnic. We banter with waitresses and gain an appreciation for the authentic brand of hospitality that they serve. We give these inexpensive meals enthusiastic thumbs up, even when we're not sure if we loved the food or just how good it made us feel.

I enjoyed diners before I wrote this book. My food writing focuses on casual dining and inexpensive meals, so diners (the places, not the people) are the perfect subjects. Now, with hours of eating, writing and researching for this book behind me, I have a greater appreciation for what diners mean to Louisville.

I was born and raised in Louisville (Shively, to be specific—Louisville Male High School, since you asked). College and a journalism career took me away before I could explore the city with the curious eyes of a young adult. By 2010, I had given up newspapering, but I wanted an avenue to continue writing. I created "Ashlee Eats," a blog where I write about frugal dining in Louisville. Visiting restaurants and blogging about my experiences showed me more about the city's diversity and character than I had ever seen as a kid. The blog was the beginning of my Louisville reeducation; this book was my extra credit.

During the summer and fall of 2014, I traveled across the Louisville metro area to learn about the community's greasy spoons, a term I use with much

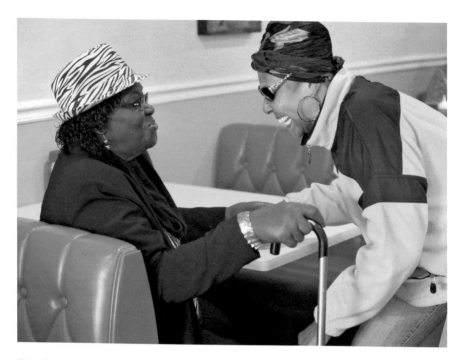

Friends Marie Fletcher (left) and Rolinda Bentley catch up during lunch at Franco's Restaurant and Catering. *Photo by Jessica Ebelhar.*

affection and respect. I drove inside and outside the Watterson Expressway, East End to West End, downtown to the South End. I got used to being the stranger in dining rooms full of regulars. I ate my fair share of biscuits and gravy. And from vinyl stools and cushy booths, I got to witness the soul of Louisville dining.

This book highlights diners in Louisville that have knitted themselves into the fabric of the city through decades of boom, bust and resurgence. I've used the neighborhoods of Louisville as a guide to trace the past, present and future of the city's diners. I've written about my own experiences in these diners and added some interviews and research to illustrate how important diners are to the preservation of Louisville's diverse culture.

Diners don't get nearly as much attention as some of the more upscale, nationally recognized restaurants in Louisville. Yet what diners lack in recognition, they receive in love from patrons, employees and the greater community. The success of diners depends on the customers who adopt these businesses as beacons of pride for their neighborhoods and harbors of community memories. In return, diners represent and define the people who patronize them.

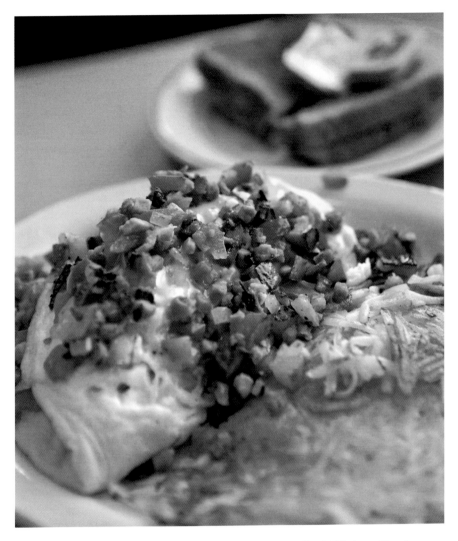

An omelet prepared western-style with tomato at Barbara Lee's Kitchen. *Photo by Jessica Ebelhar.*

The hardest part of this journey was coming up with a definition for diner. The term "diner" emerged in the early half of the twentieth century, when people began to refer to lunch wagons as "dining cars" because of their resemblance to Pullman dining cars, according to the book *Diners, Bowling Alleys, and Trailer Parks: Chasing the American Dream in Postwar Consumer Culture.* Folks eventually shortened "dining cars" to "diners," and a brand was born. Some folks base their definition of a diner on this architectural resemblance

Server Donna Browning waits on customers at Kathy & Joe's Place off Dixie Highway. *Photo by Jessica Ebelhar.*

or on other criteria, such as the inclusion of a counter that faces an open kitchen or geographic location (diners got their start in New England, so some people think this is the only area that has bona fide diners). For this book, I've adopted a broader definition of the modern diner:

> *Diner: a small, casual restaurant that meets the following criteria:*
> - *locally owned and operated;*
> - *specializes in home-style, American cuisine;*
> - *serves breakfast;*
> - *average price of an entrée is ten dollars or less;*
> - *synonyms/terms of endearment: hole-in-the-wall, greasy spoon, mom and pop*

I've also included restaurants in this book that are cousins to diners and exceptions to my own rules. These places are worth mentioning because of their reflection of some part of diner history or their cultural significance to Louisville. These diner relatives also display similar spirits of down-home hospitality.

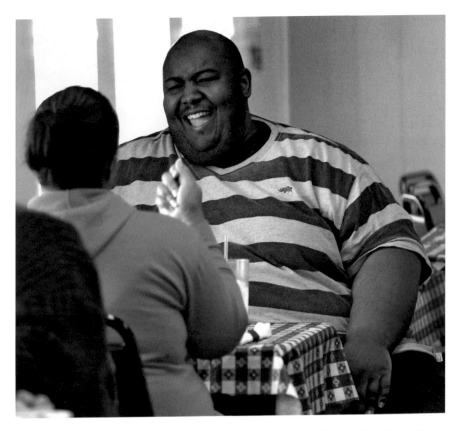

Davis Williams shares a laugh with Evelyn Tony during lunch at Kathy & Joe's Place. *Photo by Jessica Ebelhar.*

I'm not the only person with a soft spot for diners. In the course of writing this book, I've met folks who share a passion for Louisville and the food this city creates. At the end of each chapter, I've included interviews with food writers and community members to provide different views of diner eating.

This book gave me a reason to rediscover Louisville and fall in love with my birthplace. I hope the diners of this book will inspire you to explore the many sides of this city as well. Sometimes, Louisville residents can get too comfortable in the soothing bubble of our own neighborhoods and not want to branch out. For tourists, it's easy to stick to the main attractions rather than venture out to parts unknown. I encourage you to explore the city with your taste buds first. You'll love where they take you.

ACKNOWLEDGEMENTS

Thank you for buying this book. Seriously. You spent your time and money on my words, and that means a lot. Hang tight, though. I have a few more people to thank before you put down this book.

The men and women of the Louisville diner industry made this book possible. I'm honored to have gotten a chance to talk to so many of you about your lives, your jobs and your food. Your passion for food, family and community inspired me to keep writing. I hope this book does justice to the important work you do.

The Louisville Free Public Library was a wonderful resource in my research. A special thanks to the clerks on the second floor of the Main Branch, who were always happy to help me dig through newspaper archives.

Talking about food is almost as good as eating it. Thank you to Kevin Gibson, Steve Coomes, Robin Garr, Jennifer Rubenstein, Emily Hagedorn, Liz and Jesse Huot and Sarah Fritschner for giving me the opportunity to interview you.

I have amazing, inspirational groups of friends who have encouraged me since food writing was just a hobby. Thank you to all the members of the CORE, the Herald Women's Club and the Champagne and Fancy Cakes Club for your friendships. I'm lucky to have such phenomenal women in my life. The world can't hold me back when I have you guys on my side.

Beth Wilberding read some pretty rough drafts of this book. She is a wonderful editor who helped me mold this book into something I could be proud of. Thank you for your patience, encouragement, generosity and friendship.

Jessica Ebelhar and Kelly Grether are amazing photographers and blessed this book with their pictures. Thank you for sharing your skills and helping bring the story of Louisville diners to life.

Kirsten Schofield, formerly of The History Press, plucked me from obscurity (read: Twitter) and gave me a chance to write my first manuscript. Will McKay took the baton and finished bringing this book to fruition. Thank you both for having my back, even when I was freaking out over deadlines.

The faculty, staff and fellow students of Spalding University's master in fine arts program have pushed me to become a better writer. The program and the people in it gave me the confidence to get serious about my writing career. I can't wait return to workshops and residencies.

Sometimes, a woman needs to call in the professionals. Several authors gave me some great advice about publishing. Thank you to Neela Vaswani, Maggie Green, Shiloh Walker and Roy Hoffman. I also appreciate Kyle Anne Citrynell for guiding me through the legal side of becoming an author. And thank you, Dr. Vincent and Holly, for giving me much-needed perspective during this process. Without you, I would've gotten lost in my own insecurities and never finished this book. I am grateful that you've helped me become a more introspective, mindful person. And thank you to my day-job boss, Chris Tompkins. I'm grateful for your flexibility over these last few months.

I appreciate the support from the readers of my blog, "Ashlee Eats," even when I temporarily abandoned you to write this book. Thanks for hanging in there and believing that I really was working on something worthwhile.

My dog, Roscoe, has sacrificed long walks and cuddle time so I could write this book. Thanks, buddy. I owe you a belly rub.

My family is amazing. We're a nontraditional, loud bunch, but there's a lot of love under all the noise. Mommy, Daddy, Timmy, Bobby, Kelly, Kennedy and Nicholas, thank you for supporting me and cheering me on. You make me feel unstoppable.

Finally, to Robert Thompson, my husband, my best friend and my favorite eating companion. You are the almond butter to my four-berry organic fruit spread. I worried that all the life changes we've tackled lately—graduate school, this book, the police academy and impending milestone birthdays—would strain our relationship. But all this growing up has just made our marriage stronger. I would be a mess without your patience, kindness and encouragement. Every day, you inspire me to be a better person. Thank you for loving me. You're the best. Also, thank you for making me coffee before you go to work in the morning, even though you don't always take some for yourself. You really do know the way to a writer's heart.

FROM CARTS TO CHROME

A Brief History of Diners in the United States

Diners have offered just what crowds have wanted since the restaurant's beginning: inexpensive food at the most inconvenient times. We like our comfort food after a night of good times and bad decisions, before we head home after a long shift or when the only thing that will satisfy our bodies is a plate of something that's just a little bit greasy. The locations and target audiences for diners have morphed during the past 150 years, but meeting customers halfway is a recurrent theme through the birth, golden age, twilight and revival of diners.

Diners looked a lot like food trucks before they included the traditional counter, booth and table layout with which we're familiar. In the 1800s, late-shift workers didn't have many options if they wanted to grab something to eat after they clocked out—there was the saloon, their own kitchen and not much in between. In 1872, a Providence, Rhode Island man named Walter Scott noticed the limited late-night meal options, so he plugged this hole in the market. Scott cut out the sides of a wagon, attached a cover to provide him some shelter and hooked the contraption to a horse. He took to the streets of Providence and stopped at each of the city's three major newspaper offices to sell ham sandwiches, boiled eggs, coffee and pies to an eager audience, as author Andrew Hurley noted in *Diners, Bowling Alleys, and Trailer Parks*. Scott's cart was only big enough for him to serve people through the windows of his contraption, so customers milled about outside as they waited for and received their meals.

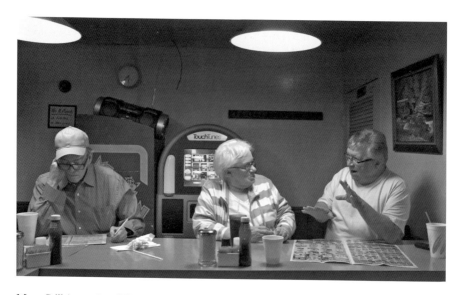

Mary Still (center) and Danny Jenkins (right) chat at Barbara Lee's Kitchen in Louisville. They've been coming to the diner for more than thirty years. *Photo by Jessica Ebelhar.*

Samuel Messer Jones expanded Scott's concept after a visit to a lunch cart in 1884. Jones bought a snack at a lunch cart after a lodge meeting late one rainy evening. The food was good, but the weather was terrible. "He wondered why no one had thought of it before—why make people stand out in bad weather to eat? Sam Jones wanted a lunch cart big enough for people to come inside," wrote Richard J.S. Gutman and Elliot Kaufman in the book *American Diner.* In 1887, Jones created the first lunch wagon that accommodated customers inside. He widened the cart's narrow design and included a full kitchen, as Will Anderson noted in the book *Where Have You Gone, Starlight Café? America's Golden Era Roadside Restaurants.* Most importantly, Jones added a counter and stools for patrons, a feature that became standard in diners big and small for years to come.

Lunch carts and wagons became popular late-night and early-morning fixtures in the early 1900s. But this new restaurant style faced its share of resistance from the community. The mobile eateries were most popular with late-shift workers in the industrial cities of New England and the Midwest, according to Hurley. But citizens complained that the businesses routinely violated their dusk-to-dawn curfews and extended rowdiness into the workday. City governments created tighter regulations to control the wagons and carts, but operators dodged the rules by putting down the brakes and establishing more permanent locations. According to *American Diner*, lunch

wagon owners squeezed into slivers of land, including at least one operator's front yard, and hid their wheels behind wood or brick so they could find a new location if business waned.

Around the same time that lunch wagons became stationary, cities abandoned horse-drawn trolleys in favor of electric streetcars. Enterprising business owners took advantage of these discarded vessels by converting the trolleys into lunch wagons. They called their innovation "trolley-lunches." Gutman and Kaufman wrote that many of the trolley-lunches were infamous for shoddy structures and sketchy clientele. The bad reputation of the trolley-lunch spread inaccurately to all diners.

Diner owners found themselves with an image problem. People didn't think of these restaurants as down-home comfort—they thought lowbrow dining. To improve their reputations, diner operators appealed to a new demographic: women. By the mid-1920s, most diner customers were men. Women tended to avoid diners because of perceived unsanitary conditions and rowdy patrons. Business owners decided to appeal to this untapped market by changing operations and features to attract women. Owners expanded their menus and softened the décor with flower boxes and frosted glass windows. The most important diner addition that we still have today is the table and booth, accommodations meant to draw in women who didn't like the uncomfortable counter stools (the stools are still just as uncomfortable). Owners even welcomed women with "Ladies Invited" and "Booths for Ladies" hand-painted signs, as Gutman and Kaufman noted.

As diner popularity climbed, building the structures became a streamlined industry. Businessman Thomas H. Buckley of Worcester, Massachusetts, began mass-producing lunch wagons in the 1890s, and other manufacturers followed suit through the 1960s, as Anderson wrote. According to *American Diner*, one company even bragged that it could produce a "diner a day," not too bad for an industry that began with a modified horse-drawn wagon.

Diners had traditionally done well by serving a faithful clientele of working-class folks. After World War II, diners in cities and near factories saw their clientele speed to the suburbs. "Joining the middle class in the stampede to the suburbs, they spent their money on both big-ticket items and small luxuries such as an occasional meal away from home," Hurley wrote. "But these newly affluent families were not content eating at just any greasy spoon. So, simple and scruffy diners had to evolve to suit the new states and needs of their expanding and upwardly mobile clientele."

Diners had to follow their customers to the suburbs to survive. Operators opened diners along major commercial streets and highways to attract

suburban residents and passing motorists. Some enterprising operators outran growing American families and set up shop in undeveloped areas that would eventually become suburbs.

To attract middle-class families into the booths, diner operators nixed the grease and adopted shiny, space-age designs flush with stainless steel, sleek lines and large picture windows, Hurley noted. Gone were the dimly lit, urban lunch wagons known for trouble. Post–World War II diners were bright bastions of casual dining near the comforts of suburban homes.

The industry also began to market diners as a way to strengthen family bonds. Marketers portrayed diners as a mealtime destination that would please every member of the nuclear family. Mom could take a break from cooking for an evening. Dad still got a hot meal. And the kids could choose exactly what they wanted to eat. As Hurley wrote, "By reorienting their businesses around the needs and aspirations of suburban families, they found a way to address customers on the basis of something other than class background."

Interestingly, the food remained mostly the same when diners got a suburban facelift. Hamburgers and hot dogs were still hits, along with more

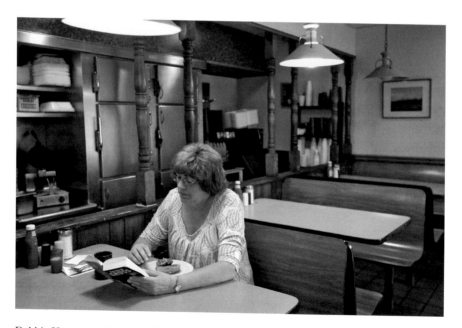

Debbie Heaster reads during dinner at Barbara Lee's Kitchen. Heaster, who moved here from West Virginia, has a close connection with the staff. "They've become my family," she said. *Photo by Jessica Ebelhar.*

ethnic dishes that immigrant diner operators introduced, such as Greek salad, spaghetti and kosher pickles, Hurley noted.

Diners became a suburban hit. In response, operators became increasingly efficient in dishing out their product to the large, steady crowds that flocked in for a meal. They added such accommodations as take-home service to increase their efficiency. But the diners' own improvements ultimately contributed to the industry's demise. A new innovation came along in the 1960s and 1970s that doled out food in a uniform, rapid manner with which diners had a hard time competing: fast-food restaurants.

A glance at some the popular strips of restaurants in Louisville would make it seem like diners evaporated from the city's restaurant scene in the wake of fast food. But you can still find the diners if you look beyond the bright lights of Frankfort Avenue, Bardstown Road and East Market Street. Louisville diners succeed in the corners of the city that, unfortunately, are sometimes missing on tourists' maps. They embody the most important part of the diner tradition: providing affordable food when hungry folks need it the most, wherever they are.

Part 1

THE PAST

Old Louisville

After a night of watching *Golden Girls* DVDs, I woke up well into Saturday morning with waffles on my mind.

Many weekends began like this when I lived in Old Louisville. Two other former journalists and I bunked together as we figured out what our next steps into adulthood would be. They were further along in their self-discoveries—Samantha was in law school, and Susie was in graduate school. I worked at a nonprofit and fretted over whether my professional life had peaked at age twenty-one. This fretting often led to avoidance. And avoidance led to binge-watching *Golden Girls* and eating my feelings. On this particular Saturday, my feelings called for waffles.

My roommates enjoyed our converted Old Louisville apartment for its proximity to the University of Louisville, which they both attended. I loved how close we lived to a twenty-four-hour diner. I fumbled for my phone and the carryout menu I had grabbed during my last visit to Burger Boy. I called in my order of waffles. I leashed my dog, Roscoe, and we walked the block and a half to Burger Boy at the corner of Burnett Avenue and Brook Street.

A slice of Old Louisville was on display that morning. The day landed on the sweet spot on the Ohio Valley calendar when the humidity from the summer has wandered away but the fall chill hasn't moved in yet. The crowd outside occupied most of the tables on the sidewalk, flicking the ash from cigarettes while catching up and enjoying their morning coffee. There were old folks and young of all colors and stripes, many of whom also called this area home.

I had visited Burger Boy before, but this was the first time I noticed how special Burger Boy and the diners in Old Louisville are. The community's diversity is on display when you visit an Old Louisville diner, but the differences don't matter much. The variety of housing and the proximity to two colleges (the University of Louisville and Spalding University) cram folks from all ages, incomes and races into forty-eight blocks. And all these folks need to eat. The college student's pancakes will be just as good as the homeless man's eggs. An executive's double cheeseburger will taste the same as a family of four's dinner platters. Good food served at good prices appeals to everyone. And even if it's just for the time it takes to order and eat a waffle and hash browns, everyone is the same while they have a meal in a neighborhood that time (fortunately) forgot.

Old Louisville is steeped in history, so it feels right to begin our Louisville diner journey here. Old Louisville is the only part of the city where Ollie's Trolley, a squat diner inspired by turn-of-the-century trolley cars, looks downright progressive next to the stately buildings that surround it. This neighborhood nurtures the structures that would be discarded elsewhere in favor of more modern design. Old Louisville's history and its residents' appreciation for the past create a perfect environment in which diners can thrive.

Respect for preservation in Old Louisville developed after more than 180 years of history. Old Louisville was more of a country hideaway when folks started moving south into the region from downtown Louisville in the 1830s. After the Civil War, the city swelled, and the area from First to Fifth Streets and from Broadway south to Hill Street became prime residential real estate. Churches, schools and businesses soon followed and helped the area grow into a bustling community. The biggest boon for Old Louisville came in 1883 with the Southern Exposition, according to the *Encyclopedia of Louisville*. The event included manufacturing, farming and cultural exhibits on display in the area that would later become Central Park. Hundreds of thousands of visitors flocked to the region, including President Chester A. Arthur. After the exposition, professionals swarmed the region and began to build the ornate Old Louisville homes we know today.

By the early 1900s, some of Old Louisville's luster had begun to fade. The building of new homes in the area stalled because many attractive pieces of land were already taken. Meanwhile, transportation made it easier for middle- and upper-class Louisvillians to move to developing residential areas east of the city. So families moved out of their behemoth Old Louisville homes. Landlords, in turn, spliced many of these houses into rental apartments,

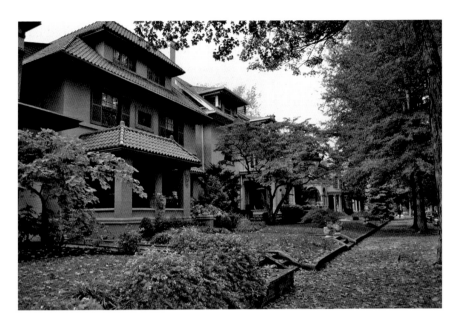

Grand homes line many streets in Old Louisville. *Photo by Kelly Grether.*

in one of which I would eventually live. The influx of renters—along with the expansion of the University of Louisville, Spalding University and a commercial district in the north section of Old Louisville—transformed the neighborhood into a more economically and socially diverse community.

Stately homes in Old Louisville had fallen into disrepair by the 1950s and 1960s. This prompted community members and city leaders to develop rehabilitation plans for the neighborhood to stop the "gradual deterioration of this inner city area," as the *Courier-Journal* reported. The renewed interest in the district earned Old Louisville a spot on the National Register of Historic Places in 1975. The neighborhood is now considered the largest Victorian district in the country.

Years of preservation have embedded the Old Louisville community with a good sense of when to leave well enough alone and when to make improvements. Old Louisville adapts, not demolishes, to retain its historical charm. The diners in this 1,205-acre neighborhood share these values in the retention of the old and adoption of the slightly different, whether it's holding on to curbside services at Dizzy Whizz or adding bison burgers to the menu at Burger Boy.

Even when I wasn't sure where my own life was headed, I knew that I could find an order of waffles and eggs right down the street. That was enough to tide me over. Burger Boy and other diners have forged

places in this community after years of serving the food that makes us feel better. In Old Louisville, the past never goes out of style. Fortunately, neither do the diners.

BURGER BOY

1450 South Brook Street
Louisville, Kentucky 40208
502-635-7410
www.burgerboydiner.com

Inside Burger Boy, everyone is waiting for the rain to pass on a dreary afternoon. A college student, long finished with his meal, studies a thick book splayed on his small table. A family of three generations discusses the merits of bison meat (most of them eventually order veggie burgers with avocado and pepper jack cheese). A woman wearing a black bandana bedazzled with rhinestones waits at the counter for her burgers hissing on the grill. Outside, sheets of rain pelt the worn homes and postage-stamp yards dotted with dandelions. The houses are worn, but the beauty shines beneath the peeling ivory paint. The light of Burger Boy's fluorescent signs makes this corner of Old Louisville glow.

Burger Boy is a bright spot at the corners of Brook and Burnett Streets in the northwest corner of Old Louisville. The diner provides a little bit of escape, a lot of neighborhood pride and a healthy portion of shenanigans on late nights. Pedestrians from the surrounding homes, the nearby DuPont Manual High School and the University of Louisville trickle into (and sometimes flood) Burger Boy twenty-four hours a day. The diner lives by the motto emblazoned on its menu: "If you're up, we're open!"

As diners expanded from carts to lunch wagons to full-blown restaurants in the first half of the twentieth century, many owners continued to serve customers around the clock. Industry was booming, and third-shift workers needed somewhere to eat. So, along with night owls simmering down after a long night out, "diners counted on third-shift factory hands, bakers, dairy workers, printers, and truckers to supply a reliable flow of customers until the breakfast trade resumed at sunrise," wrote Hurley in *Diners, Bowling Alleys, and Trailer Parks.* The extended hours created reliability that fostered camaraderie among the diverse patronage, according to *American Diner.* As

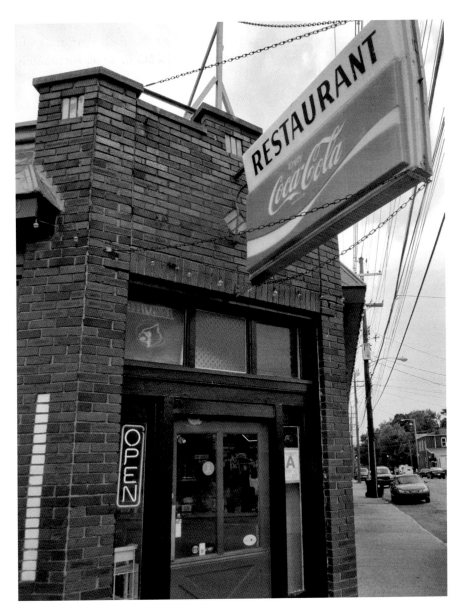

Burger Boy in Old Louisville. *Photo by Ashlee Clark Thompson.*

the night wears on and hunger takes over, who you're sitting next to matters less than eating something good and filling.

The time of day a visitor arrives at Burger Boy determines the mealtime experience. Mornings host a steady stream of customers waiting for their

first cup of coffee to settle in. Afternoons tend to be quiet. After hours, when the bars shut down but the parties are still going, Burger Boy buzzes with the last sputtering of a good night. The "Munchies" section of the menu, filled with foods served deep-fried and usually covered in cheese, speaks volumes about the preferences of the late-night demographic. There are cheddar cheese fries ($3.99), mozzarella cheese sticks ($4.49) and jalapeño cream cheese poppers ($4.29) for folks with iron-lined stomachs. The chili cheese fries ($4.49) have enough grease, protein, starch and cheese to provide a hearty base (or cap) to a night of drinking.

Burger Boy's roots extend back to the 1930s, when the building housed A.R. Orthober's Market, according to the brief history on the diner's menu. The Market eventually became Greg's Place Restaurant in the '60s and '70s. In 1981, Juanita's Burger Boy began to serve a lineup of greasy fare fit for the college students and partiers who made their way into the diner. Dan and R.J. Borsch took over ownership after the eponymous Juanita retired in 2008.

The new owners slowly revamped the diner while keeping the traits that have made it famous: 24/7 service, the burgers and the name. The physical changes to Burger Boy could escape the casual visitor, but they're apparent to regulars—a freshly painted black wall above the grill, a slick logo with curvy white lettering over a red backdrop, a renovated back room that provides additional seating for large groups or busy nights. The Borsches completed the renovations with precision and patience. The menu creeps outside the box without being too offending. And there are still enough diner staples to welcome regulars.

Burger Boy has allowed its proximity to the University of Louisville to seep into the dining room. There are no fewer than six U of L flags and two pennants. Red Christmas lights dangle from the ceiling of the back room. The only blue in this veritable cardinal conclave is the commonwealth of Kentucky flag. Political bumper stickers on the vent above the fryers give some clue to how this neighborhood leans: "Clean Coal Isn't," "Free Tibet" and "Say No to Bridge Tolls," to name a few.

The night of a University of Louisville football game is busy for the restaurant, especially after the crowd begins to trickle out of the relatively close Papa John's Cardinal Stadium at Floyd Street and Central Avenue. There are the students who spent the day more invested in tailgating than the result of the game. There are also a few fans who really do want to discuss the game over a meal.

Burger Boy provides just enough options to cater to such a varied crowd. Given up meat? Try a veggie burger ($4.99). Want breakfast, but your dining

Biscuits and gravy is just one of the many breakfast dishes at Burger Boy. *Photo by Ashlee Clark Thompson.*

companion prefers lunch? The menu is extensive in both categories. Hung over? Maybe you need the Burger Boy Breakfast Special with your choice of meat, two eggs, home fries, biscuits and gravy *and* toast ($6.99). Want to eat local? There's a quarter-pound bison burger with meat from the Kentucky Bison Company ($8.99). There never seems to be enough bison to feed the curious crowds—the diner keeps a limited supply on hand to ensure freshness. Ask if they have any bison before you get your heart set on your order. Go for the bison if it's available. The meat is a bit lighter than traditional beef but just as delicious.

Once you order, it's easy to settle in at Burger Boy. The jukebox along the far wall is enough entertainment for at least three songs. The warmth from the griddle and the neon lights are enough to ride out a storm or wind down after a big game.

D. NALLEY'S

970 South Third Street
Louisville, Kentucky 40203
502-588-2003
Facebook: https://www.facebook.com/pages/D-Nalleys-
 restaurant/164594503574219

Something seemed a little different during my first visit to D. Nalley's. It wasn't the other patrons. The hushed tones of two men in a corner booth were barely audible over the drive-time radio banter on hidden speakers. Another man swiped the iPad propped on his table with one hand while he drank his coffee with the other. Another man glanced at a copy of the *Courier-Journal* at the counter while he waited for the cook just a few feet away to finish his order.

It wasn't the food. A hearty plate of two eggs, two biscuits, three strips of bacon, an order of hash browns and small cup of coffee were just $6.10, and it all tasted just fine.

It wasn't the service, which was speedy and polite. Two waitresses kept the coffee mugs filled and let the customers be, not out of disregard but courtesy. Sometimes the beginning of a day needs a lot of coffee and very little conversation. These ladies understood. Then, as I reached for the pepper for my eggs, I realized why I feel a bit out of place: I was the only female customer in the diner.

I imagine that women had the same feeling when they entered diners in the 1920s, when diners were a predominantly male institution. Granted, the crowd at D. Nalley's diversifies as the day wears on, but being the only female patron reinforced the old-school atmosphere that D. Nalley's serves.

D. Nalley's opened in 1967, and the diner flaunts its age. Strips of scarlet duct tape cover slits in the matching vinyl seats. The only sweetener on the table is a glass cylinder of sugar; there are no little packets of pink, blue and yellow in sight. In case patrons don't see the "Cash Only" signs on the way in, there's a sign taped to the side of the beige cash register that beeps and clangs with every transaction. D. Nalley's likes its place in the past, so customers should respond accordingly.

The diner is a neighbor to another Old Louisville institution, Ollie's Trolley. Two diners within spitting distance of each other sounds like the makings of a rivalry. Fortunately, Ollie's Trolley and D. Nalley's have enough differences to keep the two businesses neighborly. Customers go to Ollie's

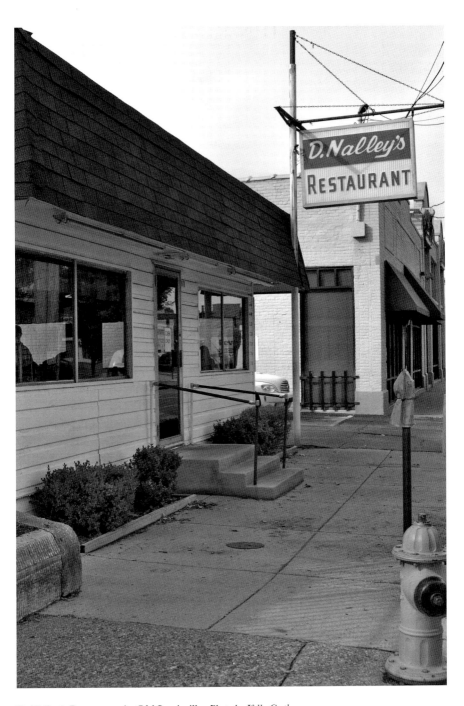

D. Nalley's Restaurant in Old Louisville. *Photo by Kelly Grether.*

when they need lunch in a hurry and on the go. Customers visit D. Nalley's when they want breakfast, lunch or dinner and have some time to enjoy it. For every facet of other diners that Ollie's lacks (seating, a breakfast menu, longer hours), D. Nalley's makes up for in spades.

The three-page menu is extensive, so a group with a wide variety of tastes can share a meal, and each person can get exactly what he or she wants. The list of sandwiches alone provides enough variety—a country-fried steak burger, BLT, patty melt and the Nalley Burger, just to name a few. If you want something similar to a Sunday dinner, the dinner platters should satisfy with choices like a T-bone steak, grilled pork chops and fried chicken.

Breakfast is the highlight at D. Nalley's. The house-made biscuits are worth keeping some cash in your wallet for an impromptu trip. The biscuits are still dusted with a bit of flour when they get to the table. They're great plain, coated in jelly or hidden beneath a blanket of sausage gravy.

You might end up in D. Nalley's keeping company with a room full of quiet, hungry, older gentlemen. You might enter to find a bustling lunch crowd of office workers throwing down lunch before they have to head back to work. Either way, a waitress will make sure your coffee mug stays filled.

DIZZY WHIZZ

217 West St. Catherine Street
Louisville, Kentucky 40203
502-583-3828
http://www.dizzywhizz.com

Dizzy Whizz was a special place for my husband, Rob. His dad would pull up to this Old Louisville restaurant, park under the green-trimmed awning and order two Whizzburgers for him and one for his son. At the end of the meal, after Rob inhaled his burger, his dad would pull out **another** Whizzburger from the brown bag for his son. He always knew that my husband, then a growing boy who would eventually shoot up to six feet, four inches, would want another burger.

Twenty years later, Dizzy Whizz still ignites a childish glee in Rob when he pulls his Camry into a slot in the carport. Dizzy Whizz is packed with memories for him and many other customers. Though the walls might be faded and the décor outdated, Old Louisville diners like Dizzy Whizz preserve special moments by retaining a vintage charm.

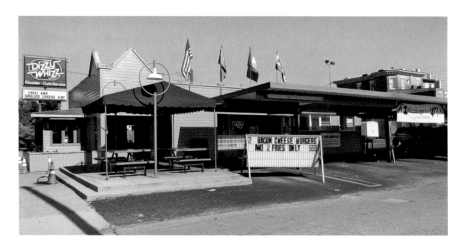

The carport of Dizzy Whizz in Louisville. *Photo by Ashlee Clark Thompson.*

Dizzy Whizz brags that it's the last original carhop left in Louisville, the only local restaurant where customers can park their car and a server will deliver orders right to rolled-down windows. The diner also offers countertop seats with a view of a griddle, a full dining room and carryout service, the same medley of dining options that Howard Poole offered when he opened Dizzy Whizz with then co-owner Garland Haynes in 1947, according to an article from the *Courier-Journal.*

Dizzy Whizz can thank the Prohibition era for at least part of its success. When the ban on alcoholic beverages began in 1920, folks looking for refreshments had to settle for ice cream sodas and root beer at fountains and lunch counters, as author Michael Karl Witzel wrote in the book *The American Drive-In: History and Folklore of the Drive-In Restaurant in American Car Culture.* Around the same time, cars had gained popularity as a mode of transportation and recreation. "People with cars are so lazy that they don't want to get out of them to eat," Dallas businessman J.G. Kirby guessed, according to the book *Car Hops and Curb Service: A History of American Drive-In Restaurants, 1920–1960.*

Kirby teamed with Dr. R.W. Jackson and created the Pig Stand in 1921, the first restaurant built specifically for serving meals to motorists. This new type of restaurant combined the search for nonalcoholic leisure with the newfound luxury of owning a car.

It's still appealing to eat in our own vehicles nearly one hundred years later. It's not because we're lazy. These days, we have too much to do. We spend about thirty-eight hours each year stuck in traffic on our way home, on

our way to work or somewhere just as important, according to *The Atlantic*. We cope with the commute with podcasts, audiobooks, satellite radio, DVD players, seat heaters and air conditioning. It only makes sense that we would welcome comfort food, as well as the comforts of technology, into what have become our second homes. We might not be able to get to our own dining room table each night, but at least we can park under the awning of Dizzy Whizz, nibble at a crinkle fry and sink into the familiar plush seats in which we spend so many hours of our lives.

Unlike the world rolling by our car windows, a lot of Dizzy Whizz's features have remained the same over the years. The building is still in its original location on St. Catherine Street. The restaurant's most famous menu item is still the Whizzburger, a double-decker cheeseburger with tartar sauce that Poole introduced in 1953, according to the *Courier-Journal*. And the drive-in is still a popular mealtime option.

"Dizzy Whizz has over the years been able to create a niche here," says Tim Poole, the current owner/operator of Dizzy Whizz. He took over operations from his dad, Howard, in the 1980s. "It has branded itself well in Old Louisville. And that's been very important to us."

Dizzy Whizz isn't completely immune to change. A second Dizzy Whizz location at Third Street and Broadway closed in 1986. And the alley that

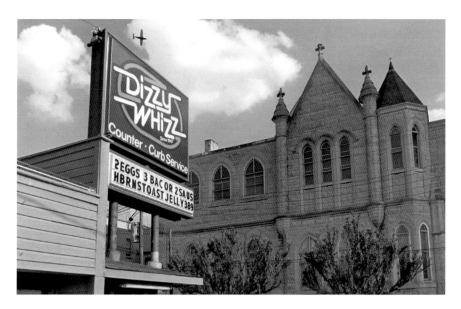

Walnut Street Baptist Church neighbors Dizzy Whizz in Old Louisville. *Photo by Ashlee Clark Thompson.*

runs parallel to the restaurant received a new name in 2000, Howard Poole Alley, as the *Courier-Journal* reported in 2000.

The restaurant's commitment to inexpensive food also keeps people pulling into the carport. Along with the Whizzburger as its showcase, Dizzy Whizz boasts a wide array of sandwiches, from the basic (hamburger, grilled chicken, fish) to the indulgent, such as the Chuck Wagon (a breaded veal patty on a bun, $2.99) and the Gutt Buster (a half-pound beef patty topped with spicy sausage and two slices of cheese, $6.79). For a couple bucks more, you can add a side of French fries and coleslaw to each sandwich for a basket meal. There's also a full breakfast menu, and everything on it, including the Big Whizzy Special (three eggs, bacon or sausage, grits or hash browns and toast and jelly), is less than $5.00.

"People realize that it's good food at a good value," Tim Poole says. "And I think nowadays with the economy and where the job market is, people have now reached the point where they have to watch spending on what they eat."

If you drive a small car like my Corolla, a little more elbowroom to fully dedicate my whole body to a meal is more appealing than the dread of dropping a glob of tartar sauce and shredded lettuce on cloth seats. That caution warrants a trip to the dining room, which is as packed as the parking lot on a warm summer evening. Patrons maneuver around chairs and toddlers to find empty tables. Everyone keeps an ear cocked toward the kitchen, where an employee calls out orders. There are no TVs in the dining area. No radio, either. The inside of Dizzy Whizz hums to a rhythm of harried employees punching in orders, tossing fries into grease and smashing burgers on a griddle. On top of it all, the tune of engines and sirens from the street creeps into the dining room.

A little bit of everyone takes their turn at the ordering window—office workers, blue-collar workers, salespeople, neighborhood people and people just passing through Old Louisville. They all receive their orders in to-go containers and paper bags, whether the customer is in their car or the dining room. Those containers do make the perfect makeshift platter—burger on one side, fries on the other and a swirl of ketchup in a corner.

For those who live on the edge or have places to be, go ahead and enjoy a Whizzburger in the car. Flip on some NPR. Just don't forget to ask the server for extra napkins—and maybe an extra Whizzburger, too.

OLLIE'S TROLLEY

978 South Third Street
Louisville, Kentucky 40203
502-583-5214

It took some ingenuity to see potential in an abandoned streetcar. In the early 1900s, when cities abandoned horse-drawn trolleys in favor of electric streetcars, business owners converted these discarded vessels into lunch wagons. They called their innovation "trolley-lunches."

The resourcefulness ended in the idea phase. Many of these trolley-lunches had "dark corners, drafts, and leaky roofs" and were so "unattractive and uninviting to the general public, they began to cater to an even less reputable type of night trade," according to *American Diner.* This bad reputation led to a short life for the trolley-lunch diner.

Trolley-lunches became more of a novelty than a permanent fixture. That didn't dissuade diner owners from repeatedly giving the concept a shot. They began to build new structures modeled after trolley-lunches rather than convert existing trolley cars. These not-quite-trolley-lunches were improvements and paid homage to the originals. This form eventually gave birth to Louisville favorite Ollie's Trolley. Ollie's came along well after the trolley-lunch saw its initial rise, but the restaurant uses a bit of nostalgia to draw folks in.

The design of Ollie's Trolley recalls a time when trolleys roared up and down the streets—a fire engine red roof with edges curve up toward a sign bearing the restaurant's name in serif gold lettering. If you take away the black metal steps, replace the brick foundation with a few wheels and add a little imagination, you can almost see this oversized trinket box zip through Old Louisville.

At one time, Ollie's Trolley locations had taken up residence in a handful of states, and the chain was poised to become the next Kentucky Fried Chicken. In the 1930s, Oliver Gleichenhaus ran a successful restaurant called Ollie's Sandwich Shop. In 1971, John Y. Brown, a Kentucky businessman who helped build Kentucky Fried Chicken into a fast-food giant, paid $1 million for Gleichenhaus's "secret" recipe of thirty-two spices and a special sauce that tops Ollieburgers, the *Louisville Times* reported. According to the *New York Times'* obituary for Gleichenhaus, Brown "then introduced the Ollieburger through his Lums restaurant chain, a new chain called Ollie's and mobile restaurants called Ollie's Trolleys." The trolleys only occupied

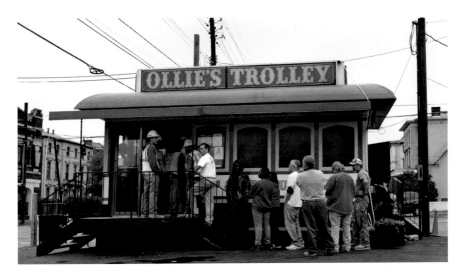

Ollie's Trolley in Old Louisville. *Photo by Jessica Ebelhar.*

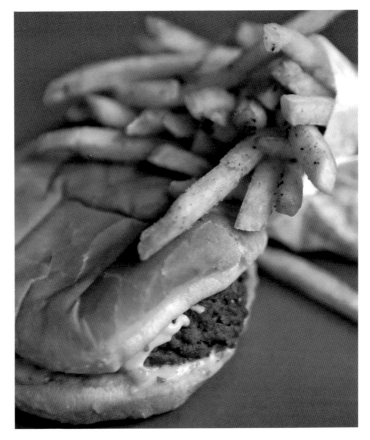

An Ollieburger
and fries at
Ollie's Trolley.
*Photo by Jessica
Ebelhar.*

the equivalent of three parking spaces per unit, and they popped up in parking lots and shopping centers across Louisville. By November 1974, there were fifty-six Ollie's Trolleys in seven states. Twelve of them were in Louisville, according to the *Louisville Times*.

"While [Brown] doesn't know 'if lightning can strike twice,' he thinks the trolleys have 'national potential' and perhaps even the 'makings of another Chicken,'" noted a *Courier-Journal* article from August 19, 1973.

Just one year later, the forecast for Ollie's Trolleys was grim. "Remember the talk about Oliver Gleichenhaus, the man with the perfect hamburger?" the *Louisville Times* asked on November 1, 1974. "Remember how John Y. Brown Jr. was going to make him famous, like Col. Harland Sanders, and Ollie's Trolleys were going to be restaurants with short menus and long lines? Well, the menus have been short. The trouble is, the lines have been, too, in some cases. And Oliver Gleichenhaus, while he does appear on television once in a while, is hardly an instant celebrity."

At the time, Peter G. Sampson, chairman of the board of Ollie's Trolley's Inc., had a few ideas about why Ollie's didn't take off. In 1974, Sampson told the *Louisville Times* that his group built too many restaurants too fast, the burgers were too spicy for some customers and some people were reluctant

Granville Smith (center) waits for his order at Ollie's Trolley. *Photo by Jessica Ebelhar.*

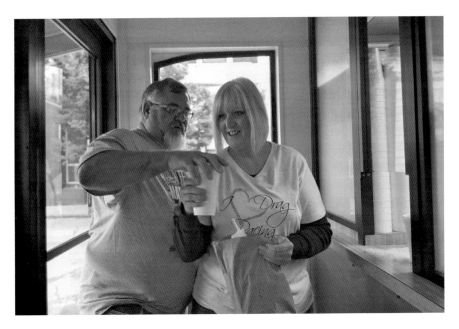

Jeff and Regina Henderson get their lunch at Ollie's Trolley. The couple, who drove two hours to get lunch there, had their first date at an Ollie's in Danville, Kentucky, thirty-seven years ago. *Photo by Jessica Ebelhar.*

to pay one dollar for the Ollieburger. Sampson acknowledged that food preparation was inconsistent because processes weren't standard from trolley to trolley.

"We've had a great deal of trial. Wherever we put the trolley, you'd think of it as a cute little marketing thing. People see it as like a little doll house. They want to go inside and see what's in there. So we get a lot of initial trial, then the sales will level off," Sampson told the *Louisville Times*. The paper went on to note that Ollie's Trolley executives were "confident that once they 'refine the concept,' Ollie's Trolleys will again go clanging along." Brown went on to become the governor of Kentucky. Ollie's never saw as much success.

The chain's failure to sink into a national market ultimately allowed the restaurant to become a hit in Old Louisville. For Louisville natives, Ollie's Trolley feels like it could never be anywhere else but at the corner of Third and Kentucky Streets. It's hard to find an Ollie's Trolley that survived the chain's bust, so a visit to the Louisville location is a special occasion. Ollie's doesn't have to worry about being consistent with its brother franchises. Instead, the restaurant can just focus on slinging out juicy burgers and fries.

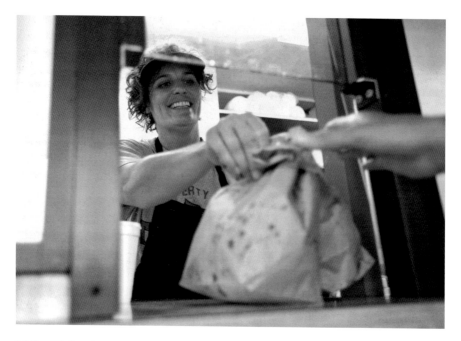

Melissa Hodge gives a customer his order at Ollie's Trolley. *Photo by Jessica Ebelhar.*

Elusive parking and limited hours make Ollie's even more of a treat when you can finally get in the door. The restaurant sticks to a menu that centers on the Ollieburger and doesn't veer much off track. Simplicity is a virtue here. The bells and whistles are long gone with the era of the trolley car.

"It's inviting to come into, even though there's no place to sit. It's comfortable, laid-back type of food that you know what you're getting, and it's cheap," says Kevin Gibson, a Louisville-based food and beverage writer.

Ollie's Trolley stops short of allowing room to eat inside. The order and pickup area is about the size of a walk-in closet. The space only accommodates customers standing shoulder to shoulder. Behind a thick plastic partition, about four employees man the griddle and take orders.

The Ollieburger ($3.20 if you want it dressed) is good enough to draw a line that snakes out the door and around the building during a typical weekday lunch. The patties are thick and covered in a sauce that is reminiscent of Thousand Island dressing. Even better are the fries, which are coated in a secret seasoning mix that is also blended in with the burgers. It's harder to taste the herbs and spices under the special Ollieburger sauce, but they're on full display atop the fries ($1.75). Even a close visual inspection doesn't reveal exactly why this spice mix is so good. Is that coriander? Rosemary?

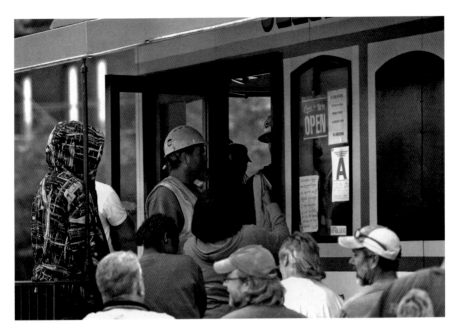

Customers line up to grab lunch at Ollie's Trolley. *Photo by Jessica Ebelhar.*

Sage? About three fries in, hunger overtakes my curiosity. This is when I stop studying the little pieces that make up this mix and just appreciate how the secret combination elevates regular French fries to an irresistible side dish. It would be a sin and a shame to put ketchup on them—enjoy them in their natural state.

Trolley-lunches and the Ollie's Trolley chain might not have made much of a dent in the national dining scene, but the little red car has rolled home in Old Louisville.

SPOTLIGHT ON OLD-FASHIONED DINERS

There are plenty of diners outside Old Louisville that are steeped in tradition. Here is a taste of some other Louisville restaurants that embody the spirit of old-school diners.

Barbara Lee's Kitchen

2410 Brownsboro Road
Louisville, Kentucky 40206
502-897-3967

It doesn't get more diner than Barbara Lee's Kitchen. The restaurant's open for twenty-four hours and serves breakfast around the clock. Two eggs and bacon will only set you back about $5.50. There's a long counter and booths so close to the griddle you could reach over and scramble your own eggs. The décor, which is heavy on the wood paneling, reminds me of a basement rec room. And the staff makes you feel like you're the most special customer they've ever come across.

"I like making people happy when I bring their food to them," says Melody Puckett, who has worked at Barbara Lee's for nine years. I meet Melody in the middle of a slow evening. She flips bacon as she tells me how much she enjoys the work at the diner. Her smile is as bright as her pink hairnet. Melody jokes that she's been at the diner so long that next year she'll "be part of the furniture," but she doesn't mind. She's found a family in her customers and co-workers.

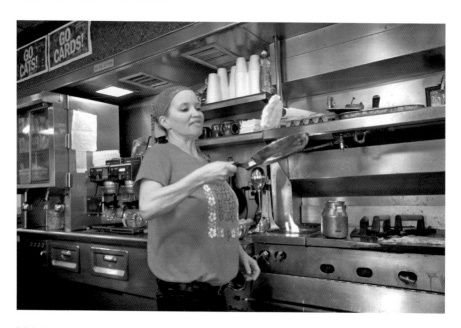

Melody Puckett flips an omelet while working the evening shift at Barbara Lee's Kitchen. *Photo by Jessica Ebelhar.*

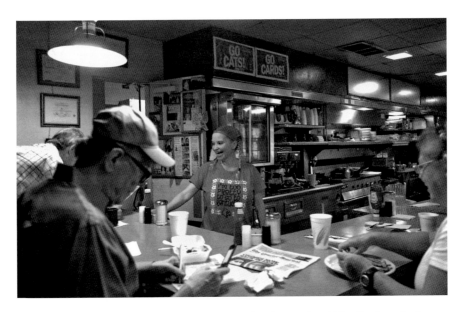

Melody Puckett laughs with customers while working the evening shift at Barbara Lee's Kitchen. *Photo by Jessica Ebelhar.*

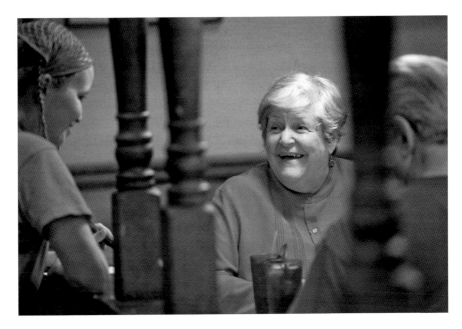

Customer Donna Thompson (center) chats with Melody Puckett (left) at Barbara Lee's Kitchen. Thompson and her husband, John (right) have been coming to the diner since 1971. *Photo by Jessica Ebelhar.*

"It makes it nice to come to work, and the employees are like one big happy family," Melody says. She flips a few strips of bacon onto a paper towel. "We all work together, and we all watch each other's backs."

Same goes for customers. The staff makes you feel cozy, whether it's refilling coffee or calling you "Sweet Pea" on the way out.

"I love my customers," Melody says. "They keep me entertained."

Twig and Leaf

2122 Bardstown Road
Louisville, Kentucky 40205
502-451-8944

For a brief moment, a diner called Twig and Leaf was in trouble.

In 2010, a group of developers expressed interest in putting a CVS Pharmacy at the north end of Douglass Loop in the Highlands. The pharmacy would have replaced the diner and other surrounding businesses. *The Highlander* newspaper reported that the announcement of these potential plans set off public debates on the fate of the Twig and Leaf, which had been a Highlands fixture since the 1960s. A few months later, the developers abandoned their plans. The controversy prompted citizens to successfully petition for the building that houses Twig and Leaf to be designated as a historical landmark.

The developers may be gone, but Twig and Leaf has plenty of work to do to stay relevant on this bustling corner of Bardstown Road. Newer restaurants, coffee shops and bars that surround the little diner are all vying for the attention of a crowd that loves to buy local. The competition over breakfast, one of the highlights at Twig and Leaf, is especially stiff. Within one block, there's a pastry shop called Breadworks; a restaurant called North End Café, which serves higher-end breakfast and brunch; and a Heine Brothers' Coffee shop, where you can grab a light morning meal with your coffee.

For now, Twig and Leaf is still a destination for a low-key meal on a lively Louisville street. Just look for the fluorescent leaf that hangs over the sidewalk.

Wagner's

3113 South Fourth Street
Louisville, Kentucky 40214
502-375-3800
http://wagnerspharmacy.com

For the few weeks before the Kentucky Derby, Wagner's is the place to see and be seen in Louisville. The diner is located right across the street from Churchill Downs, the iconic racetrack where one of the world's most famous horse races takes place. Members of the horse racing industry, from the owners to the trainers and everyone in between, come to Wagner's for a hearty meal before a day at the track.

Leo Wagner opened Wagner's Pharmacy at the corner of Fourth Street and Central Avenue in 1922. The proximity to Churchill Downs gave Wagner an instant clientele. Wagner let the men who worked at the track buy cigarettes and weekly staples on credit. Wagner's business decisions "generated a friendship and loyalty that has lasted for three generations," according to the diner's website.

Wagner's dropped the pharmacy part of its operations in 2014, but not much else has changed over the years. From the outside, it's hard to see the historical significance of this old, white building with forest-green awning. Step inside, though, and things become clear. The walls of this narrow building are

Racing memorabilia covers the walls of Wagner's. *Photo by Kelly Grether.*

plastered with pictures of past Kentucky Derby winners, jockey silks and other racing memorabilia. The sizzling griddle blends with the din of the customers, who fill every booth, table and counter stool. If you have a larger party, it can be difficult to find enough room for everyone to enjoy the meal together. Traffic peaks during the week before the Kentucky Derby, when tourists, journalists, jockeys, trainers and owners descend on central Louisville for the horse race.

Patrons flock to Wagner's for filling, inexpensive food in an old-school setting. It's best to get to Wagner's before 11:00 a.m., which is when the diner stops serving breakfast. The selections are hearty and inexpensive, such as the $2.99 biscuits and gravy or the ham and eggs breakfast platter with potatoes and toast for $6.99. If you're a late riser, lunch is just as good—the grilled ham and cheese sandwich ($4.89) is a great remedy for a cold afternoon.

One last tip before you visit Wagner's: take a look at the Churchill Downs racing schedule before you plan your trip. Wagner's food stands on its own, but it also pairs nicely with a day at the track.

DISHING WITH ROBIN GARR

Food writer, Louisville Hot Bytes

If there's some Internet chatter about a Louisville restaurant, there's a good chance it's less than six degrees from a conversation that started on LouisvilleHotBytes.com. The website is most popular for its forums, where food lovers (and a few chefs) come to discuss the city's restaurants. Food writer Robin Garr created the site back in 1994. He's been reviewing restaurants in Louisville since the 1980s and has a few opinions about what really counts as diner food.

Ashlee: *What is your definition of a diner?*
Robin: Because I have lived in the Northeast, "diner" has a very specific meaning to me, and frankly, Louisville is outside that zone and doesn't really have anything that fits my definition perfectly. I'm thinking of something like the Neptune Diner in Queens, New York City, which was said to be "the diner where the other diner operators go to eat when they're not working." Historically, as I understand it, the original diners were put into old railroad dining cars, sold as surplus and parked as permanent buildings. They had a counter with a row of stools as the primary service and dining area, a

short-order cook with a classic flat-top grill behind the counter and maybe a few small tables behind the stool. The menu is heavy on breakfast items, and they are usually available at all hours, but lunch and sometimes dinner are served as well. It's blue-collar comfort food; you would not look here for creative, fusion or "molecular gastronomy" cuisine, but classics like the Reuben, corned-beef sandwiches, grilled cheese and tomato soup and such are mandatory. Gum-snapping, wisecracking waitresses (not "servers") are a distinct plus, and in metro New York, at least, the proprietor is almost always Greek-American.

Ashlee: *What do you look for during a visit to a diner?*
Robin: Friendly service, competent cooking and decent food served hot and fresh in clean, bright and sanitary surroundings are the basics. Going beyond those basics with touches like Kentucky Proud or other sustainable, local, humanely raised meats and produce would be a very strong plus for me.

Ashlee: *Describe the perfect diner meal.*
Robin: Eggs are a must, and I'd choose 'em over-easy or sunny-side up on a bed of hash browns. That's enough to make me happy, although toast with butter and jam, bacon or sausage, some fruit and, if you're a southerner, grits are worthy additions.

Ashlee: *Why are diners important to the community?*
Robin: If their prices are fair, they offer an affordable opportunity for dining out to those who may not be able to afford fine white-tablecloth dining often. If they choose to showcase sustainable, humanely raised and local fare, they serve an important food-education role. And for busy families on the go, they may make the difference between having a nutritious breakfast and no breakfast.

THE HEART

Dixie Highway

Growing up, fast-food giants were the guests of honor at the dinner table every Thursday night. My mother worked at the beauty salon until 8:00 p.m. on those days, which was her one late night of the week. As an adult, the 8:00 p.m. cutoff time doesn't seem too bad. As a kid, my mother's late night stretched through homework time, snack time and TV time until it finally collided with bedtime. My mother needed something quick, easy and portable to bring to the table before I had to go to bed. Convenience eclipsed local ownership. So, the fast-food restaurants scattered along Dixie Highway, the main thoroughfare for my southwest Louisville community of Shively, became reliable dinner companions.

My family's omission of local Dixie Highway diners from our meal rotation was an understandable oversight. When I was a kid, it was a big deal when a major restaurant or retailer arrived on Dixie Highway and an even bigger deal when they left. Not much has changed in twenty years. There are just as many chain restaurants as I remember—maybe even a few more. It's still a boon for Shively and the other communities in the South End when a national giant takes notice of Dixie Highway and validates the buying power of this area. Big names in casual, fast-casual and fast-food dining continue to take root along this roadway in the hopes of growing this region's restaurant appeal. In the years of my childhood and a healthy portion of my adult life, the corporate signage was so big that I missed the perennial diners that give substance and pride to the South End. There is a lot of good, local eating at the diners that dot the Dixie. You just have to

Dixie Highway in Louisville. *Photo by Kelly Grether.*

spot them among the abundant collection of chain restaurants, used car dealerships, big-box retailers, cash-advance storefronts and car washes that populate the roadway.

Dixie Highway is an 18.9-mile stretch of road that begins at Broadway and Eighteenth Street in the West End and slices through Shively, Pleasure Ridge Park and Valley Station. This road has earned an unfortunate reputation as the "Dixie Dieway" for the number of accidents involving pedestrians that take place here, according to the *Encyclopedia of Louisville*. In recent years, city officials have unveiled plans to make Dixie Highway safer and more attractive to visitors and residents, a change that could garner more attention and usher in new customers for the area's deserving diners.

Dixie Highway is long enough to put some space between these diners and let them nourish their own distinct communities of regulars. These eateries thrive in the shadows of their big-name competition by preserving the flavor that's unique to this chunk of Louisville. Diners here have gained a clientele so faithful that fanfare follows renovations and reopenings on a level once reserved for the big boys in the restaurant industry. The food here is born of necessity rather than innovation, but there's also a healthy dusting of novelty and creativity.

The diners that have had some long-term success in the city are located in areas like the Dixie Highway corridor—working-class outposts removed from the higher-rent neighborhoods of Louisville. These mom and pop restaurants are largely absent from the bustling restaurant districts such as East Market Street and Bardstown Road.

"Typically, [diners are] low-check average restaurants, which explains a little bit of why they're in less-than-trendy neighborhoods, less-than-wealthy neighborhoods, because they're probably not grossing a lot of revenue," says Steve Coomes, a Louisville food writer and former chef. "Ultimately, [diners are] a business—it's a numbers game, and most diners would not make it in more pricey rent areas. It's just a fact of life."

In many of these South End diners, the names and the owners have changed repeatedly over the years. No matter what the name is over the door, the community has come to expect eggs and BLTs straight from griddles of these kitchens. Customers are drawn to institutions that are familiar and homegrown, and this keeps these businesses afloat in the shadows of their big-name competitors.

FRONTIER DINER

7299 Dixie Highway
Louisville, Kentucky 40258
502-271-3663

Dixie Highway is a road built for getting someplace. If the place you're getting to is the Frontier Diner, you'll want to linger for an afternoon. This old-school diner caters to folks who appreciate both the newfangled and nostalgic, who need a place to sit awhile and who don't mind the brusque hospitality that the busy staff delivers.

People who remember the highlights of bygone eras would like the Frontier Diner. There's so much nostalgia in this small restaurant that it feels like you've been here before, even if you're a first-time visitor. The vintage Coca-Cola–themed décor is familiar and comforting. A door painted with an old Coca-Cola logo welcomes the tired and the hungry into the compact dining room. The walls are covered with Coca-Cola wallpaper—black-and-white pictures of the soft drink's advertisements repeated every few inches and the iconic red insignia stamped throughout the pattern. The black, white and red color scheme continues into the booths, tables and counters, where customers can look at menus that are already waiting for them.

Customers mostly fend for themselves at the Frontier Diner, and that works just fine. Two waitresses manage to keep the restaurant running and everyone happy. They wear T-shirts with black half-aprons tied above their

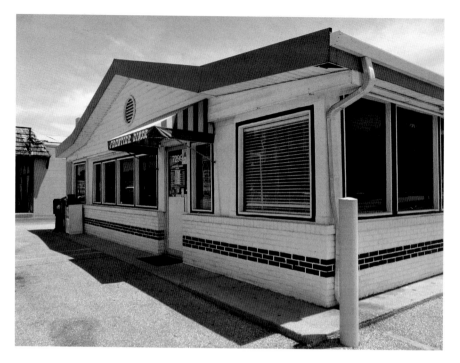

Frontier Diner in Louisville. *Photo by Ashlee Clark Thompson.*

hips that hold bundles of straws, order pads and tips. They have no time to babysit. There's silverware to sort and wrap in napkins, jelly and jam packets to pile in ceramic bowls on each booth and the bell at the kitchen window to listen for. Paper towels, like the jellies, jams and sugars, are right there on the table. But the ladies aren't too busy to fill a to-go cup with Diet Coke for my ride home.

The old mingles with the new at the Frontier Diner. People still read the *Courier-Journal* here, a newspaper once the bastion of Louisville life. The big news today is that the Binghams, the family who sold the *Courier-Journal* to a big corporation in the 1980s ("It ain't been as good since" is a common refrain in Louisville), have put the family mansion up for sale. It's a real estate transaction important enough to feed the diner fodder for an afternoon. While three women pass along the front section of the paper and remind one another of the power that the Binghams once had, an older woman nearby slides her finger across the screen of an iPad as she eats her eggs.

The Frontier Diner is a great place to order breakfast at any time of the day. If you order the biscuits and gravy, split the golden-topped biscuits in half and sling the gravy over the biscuits with a spoon. The diner's three-egg

omelets also make for a filling meal. The omelets take up half a plate and stand high above the hash browns that come on the side. A fork slides into the fluffy eggs with ease. Remember to save some room for the day's dessert. I'm partial to the peach cobbler, a syrupy, doughy dish fit for a summer evening. Nothing about the meal is over the top or especially memorable—it just hits a spot you didn't even know had.

The staff tolerates special orders. The cook or the waitresses make adjustments seamlessly—no mayo, extra mustard, canned pineapple instead of the canned peaches on a saucer of cottage cheese. The cook works behind a chrome frame, just a head and torso bobbing back and forth like a duck floating on a pond. He summons the waitresses with a bell, and the short bursts of sound interrupt the diner's midday rumble. He stabs the copy of the receipt onto his silver metal spindle.

"Can I get some pickle spears, please?" one of the waitresses asks.

"No." He disappears out of the frame. The pickle spears arrive on the next plate out.

The days roll on much like this at the Frontier Diner. Genuine hospitality drives this restaurant, with a little bit of diner sass poking through the seams.

GOOD OLE' JESSIE'S DIXIE DINER

9609 Dixie Highway
Louisville, Kentucky 40272
502-937-6332
http://www.goodolejessies.com
Facebook: https://www.facebook.com/goodolejessies

Pay attention to the stoplight attached to the front of Good Ole' Jessie's Dixie Diner. A red light means the restaurant is closed. Yellow means the doors will close in about thirty minutes or so. Green light? Come on in. Just brace yourself for an assault on the senses.

The lighting is dim, but the décor is bold. It's hard to find a square foot of ceiling, wall or countertop without a sassy sign, a metal star, a photograph of the original Miss Jessie or a spray-painted picture. The result is a little bit biker bar, a whole lot of Pinterest and a dash of a well-curated yard sale, all before you even get a seat. The loud decorations match the energy that pulses from Good Ole' Jessie's Dixie Diner, a reboot of a South End institution.

"You have to do something out of the ordinary," says Tom Whitted, the owner/operator of Jessie's. "What we have at Jessie's is special. It just came together really neat."

Good Ole' Jessie's Dixie Diner, located right on Dixie Highway just north of Meijer, is in the middle of a spirited revival that pays tribute to its long history of serving the South End. Jessie's cradles memories for many folks in the area of Valley Station. Diners like Jessie's are a testament to years of first dates, birthday dinners and fun afternoons hanging out with friends. It's more than just business at the tables and counters. Jessie's and other diners are living memory books for their communities.

The menu reveals the tale of how Jessie's evolved into a good ole' diner. In 1924, 9609 Dixie Highway was less greasy spoon and more plain ol' grease. Warren Hardy operated a garage that he built from a Sears and Roebuck kit. Warren's son, Frank, bought the property in 1951 and opened Frank's Dixie Drive-In. The simple menu and proximity to Valley High School made this place such a popular local hangout that Frank had to add indoor seating to accommodate everyone. Frank moved on to sell cars in the late 1950s, a decision that ushered in two decades of various restaurant operators leasing the Hardy property (an ice cream parlor and Mexican restaurant were two of the businesses that made a home at the location). In 1974, Loretta Jean Jessie opened Jessie's Family Restaurant, and it became a local favorite. Loretta retired in 2002, and a group of business partners operated the restaurant until 2012. The building sat empty for two years, just a blink in its deep history, but long enough to make folks miss this gathering place.

Tom Whitted, a businessman with restaurant industry experience, had eaten at Jessie's about ten years earlier and could tell then how important Jessie's was to Dixie Highway. When the business shuttered, Tom saw an opportunity to save a diner that had become etched into the folklore of Valley Station. "It's about tradition for these people," he says of the customers. "It's hard to explain. It's beyond normal in a cool way."

It was a big to-do when Tom reopened Jessie's doors in June 2014. Louisville mayor Greg Fischer came to the grand opening. The *Courier-Journal* wrote an article that

If you're heading south on Dixie Highway, Jessie's is on the left at an intersection that doesn't have a light. Turn around in the Meijer's parking lot at the next light if you're a little finicky about left-hand turns across a busy street.

lauded the return of this South End institution. And customers were just plain happy to maneuver into the small parking lot for a bite to eat.

A big part of the current clientele is patrons of the old Jessie's who are eager to reminisce. During one busy weekend morning (it seems like just about every weekend morning is packed), an older gentleman within earshot spent a chunk of his meal telling the young adults and couple kids at his table about how the new Jessie's compares with the old. Survey says: They're pretty identical.

"It's all the same," the customer observed with wide-mouthed awe. "The dining area is the same, the kitchen is the same." He paused to self-censor a memory for his younger meal companions. "We'd stay out all night Saturday, then come in here to eat."

Tom wants to make Jessie's a South End family destination. The ragged woods behind the restaurant will eventually host outdoor movie nights. An extra building in the back could be the future home of a country store and bakery where Jessie's could sell pies to folks more inclined toward dessert than dinner. "I feel like I'm part of something that's bigger than me," Tom says. "I just feel like I'm a caretaker for something that deserves to be open."

Tom has little time and lots of energy. His neck and wrists are covered with enough sterling silver skulls to make celebrity chef Guy Fieri jealous. Stand him against a wall, and he'll blend into the metal signs and patriotic paraphernalia. One minute, he's giving instructions to a member of the kitchen staff who's fumbling with some equipment on the fritz. The next he's patting a patron on the back, thanking him for the repeat business that feeds diners like this one. I get the feeling that he's always busy but polite enough to give me a few minutes of his time.

"What can I help you with?" Tom asked with the southern hospitality of wanting to help your neighbor even when you're in the middle of a to-do list at least ten items deep. There's never enough time and always something to do when you're trying to reinvigorate a legendary business.

The menu, which is still undergoing some tweaks, is full of modern creations and old favorites. Many items pay tribute to the neighborhoods of the South End—PRP Pancakes ($7.29), the Valley Fresh Sandwich ($9.99) and, of course, the Dixie Benedict ($9.99), the Dixie Omelet ($10.99) and Dixie Salad ($11.99). I'm pretty sure that classics like the Jessie's Scratch Biscuits-N-Gravy ($5.29) and the Western Omelet ($8.49) will do just fine. And I hope the Chicken and Waffles ($8.49) becomes a popular item as the restaurant finds its niche. Two steaming hot white-meat tenders sit atop two dense, sweet waffles. The well-seasoned chicken dipped in syrup is the star of this meal.

The new Jessie's also infuses some quirky creations that take risks as bold as the diner's decorations. Is the South End ready for dishes like the Sweet Burger ($9.99), a steakburger with cream cheese, cranberry wasabi sauces, caramelized onion and jalapeños? How about the Bacon Shrimp Skewers ($6.99), an appetizer of teriyaki-glazed, bacon-wrapped shrimp on coleslaw? Tom thinks so. "You want to have a little bit for a lot of different people," he says.

Whatever flavors Tom settles on, Jessie's already has the green light from the South End.

KATHY & JOE'S PLACE

5408 Valley Station Road
Louisville, Kentucky 40272
502-935-5323

Kids and adults in fluorescent yellow T-shirts are scattered throughout the dining room of Kathy & Joe's Place when I stop in one Saturday. A ribbon is printed on the front, the kind that commemorate causes like autism awareness or AIDS research. The back reads, "#TeamMia," a wink to the ever-present Twitter hashtag. This reference to social media seems out of place at an understated diner with an older clientele (on this morning, at least).

I pay my tab at the counter and ask the hairnet-clad woman behind the register about the shirts. "A friend of mine's little girl has brain cancer," she says, "so we're doing what we can to help out."

I found out later that the woman with the hairnet was Kathy Langnehs, who co-owns the restaurant with her husband, Joe. At this diner right off Dixie Highway in South Louisville, the couple has created a nest of hospitality and warmth alongside an impressive menu of home-style breakfast, lunch and dinner meals. Folks still look out for one another at Kathy & Joe's Place, whether it's topping off a half-filled cup of coffee that's not even lukewarm or raising money for a little girl's cancer treatments. You do what you can for those who cannot. That camaraderie seeps into every dish and makes a visit to Kathy and Joe's Place something special.

"We're like going home. That's what I tell people," Kathy says. "We want you to feel like you're at your house. We treat you like family, and

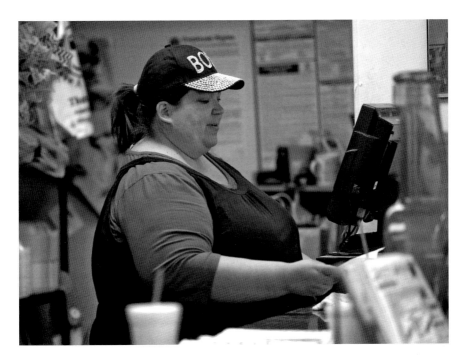

Kathy Langnehs, who owns the restaurant with her husband, Joe, rings up customers at Kathy & Joe's Place. *Photo by Jessica Ebelhar.*

that can be a good thing or a bad thing depending on what type of family you come from."

Diners had to work hard to evolve into family-friendly restaurants like Kathy & Joe's. The end of World War II prompted the baby boom and created a burgeoning demographic for diner owners: families. However, some customers feared that moving a ritual as important as dinner out of the home would ruin family intimacy. So, diner owners marketed a meal at a diner as a "ceremonial testament to core family relationships," as Andrew Hurley wrote in *Diners, Bowling Alleys, and Trailer Parks.* They promised mothers a break from housework and the rest of the household a chance to choose a meal that they wanted to eat. In the glow of postwar family values, diners appealed to suburban families.

I can barely see the suburbs when I pull into the drive of the parking lot behind Kathy & Joe's. The diner's neighbors on Valley Station Road are a mechanic's shop, a storage facility, an insulation installer and an insurance agency. Kathy & Joe's Place, which is in a long white building with sculpted shrubs that hug the perimeter, looks and feels like a single-family home. From

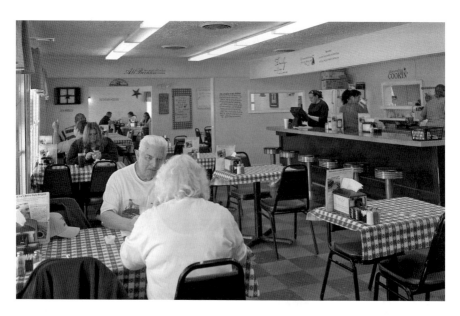

Larry and Sheila Coppala (front left) eat chicken and dumplings at Kathy & Joe's Place. The Coppalas say that Joe knows exactly what they want when they come in and brings it to them before they even have to ask. *Photo by Jessica Ebelhar.*

the back entrance, a short hallway next to the kitchen leads me to the large dining room. Unlike other diners, the counter and stools aren't the main architectural features. Instead, two-, four- and whatever-size-you-need-it-to-be tops are spread throughout the dining room so groups of various sizes can find a quiet corner to spend a meal. If we're comparing Kathy & Joe's to familiar chain restaurants, this diner feels more like a Golden Corral than a Waffle House.

Then there are the inspirational sayings. There are dozens of them painted in a deep red all over the cream-colored walls. "It's the moments together that change us forever," one reads. "Remember, you can't reach what's in front of you until you let go of what's behind you," states another. The simplest motto represents what Kathy & Joe's is all about: "Faith, Family, Friends."

For many of the past forty years, the building at 5408 Valley Station Road was the Country Cottage and Mr. Lou's Country Cottage, according to the *Courier-Journal*. Meanwhile, Kathy was cooking. When she was four, she got her first play kitchen set and pretended to be the Julia Child or Cajun chef Justin Wilson (of "I gar-on-tee!" fame). By the time Mr. Lou's closed in 2010, Kathy had gained a reputation for her cooking, and her fans saw an opportunity in the shuttered restaurant.

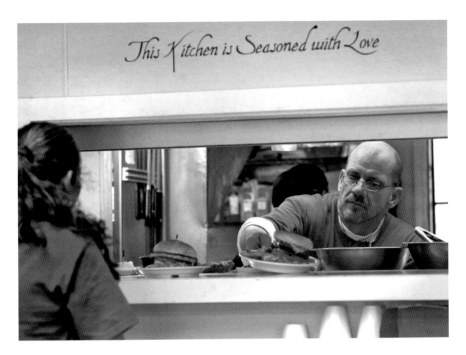

An order is ready at Kathy & Joe's Place. *Photo by Jessica Ebelhar.*

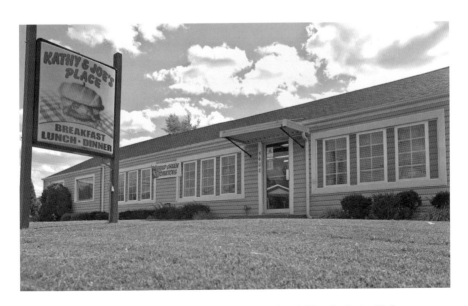

The exterior of Kathy & Joe's Place on Valley Station Road. *Photo by Jessica Ebelhar.*

"I had been cooking dinners at church on Wednesday nights for four or five years," Kathy says. "People said, 'You should start a restaurant, you should start a restaurant.' And we thought, 'What if we did?'"

Joe quit his job and cashed in his 401K so the couple could open their own diner. But two weeks after the couple signed the lease for the building, Kathy's mom, Wanda Grider, was diagnosed with pancreatic cancer. Wanda had been her daughter's biggest champion when it came to opening the diner. "We were going to back out, but she said, 'Don't you dare. This is what you need to do,'" Kathy says.

Kathy & Joe's Place opened in March 2012. Kathy's mom passed away that May. Memories of the restaurant's first fan inspired many of the menu items, including the decadent selection of pancakes, French toast and waffles. Some of the pancakes don't seem too out of the ordinary, such as blueberry ($6.99), cinnamon roll ($6.00) and pecan ($6.00). But then there is the raspberry zinger with coconut and whipped cream ($6.50), the cookies and cream ($6.00), the Boston cream ($6.00), the orange creamsicle ($5.50) and the strawberry cheesecake ($6.50), to name a few. Let's not even talk about the Elvis pancakes ($6.99), which are topped with grilled bananas, peanut butter syrup and crumbled bacon.

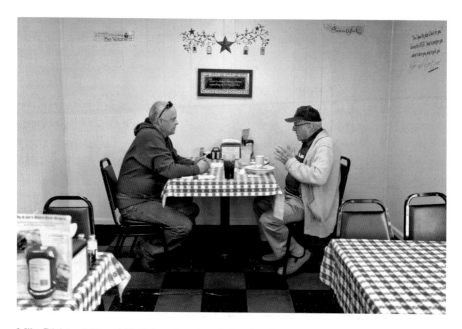

Mike Richter (left) and his father, Art, chat during lunch at Kathy & Joe's Place off Dixie Highway. *Photo by Jessica Ebelhar.*

"I always knew we wanted to have a lot of different pancakes," Kathy says. "And pancakes always reminded me of Mom."

Customers appreciate the outrageous and original flavors. "It's just something to catch people's attention," Kathy says, who is contemplating a s'mores-flavored dish. "Pancakes are something of an emotional item. Most people relate pancakes to Saturday mornings watching cartoons, when their mom made their pancakes."

The novelty of a kooky pancake attracts many first-time customers. Once their heads come down from a sugar high, they turn to the more traditional menu. They are quick to tell Kathy which recipes work and which she should put away. "Most of our menu changes came from feedback," Kathy says. "When it comes to food, people will tell you what they like. We've done a lot of experimentation. We've done some crazy things; we've done some normal things."

There was the bacon bourbon jam over chicken with fried green tomatoes on top. A customer liked it so much that he wanted his own jar of the jam. But the chicken caprese? Not so much. "That didn't go over too well. It was a fail," she says. "This was just not the right location for that. But other things we've tried, like the fried green tomato BLT we tried as a special, people loved it. We try to keep it mostly with things the general public was familiar with."

My favorite dish is an old favorite—chicken and dumplings, a special Kathy & Joe's Place serves on Saturdays. Any one-pot dish that combines

Cheeseburgers are ready for customers at Kathy & Joe's Place. *Photo by Jessica Ebelhar.*

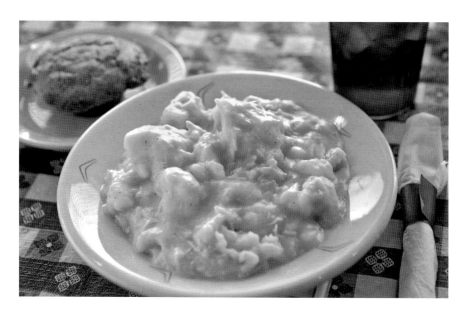

Chicken and dumplings served with cornbread and iced tea at Kathy & Joe's Place. *Photo by Jessica Ebelhar.*

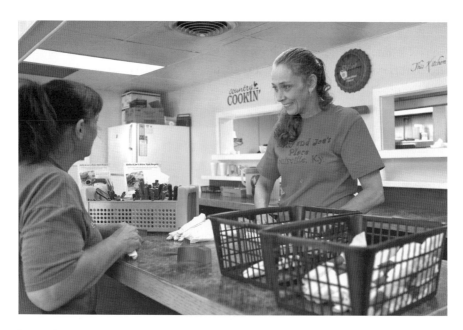

Donna Browning (right) and Donna Geist roll silverware at Kathy & Joe's Place. *Photo by Jessica Ebelhar.*

meat, vegetables and carbs is a winner to me. It's a simple meal that's hard to mess up, yet Kathy & Joe's makes it sing. The strips of chicken are fall-apart tender in a steamy, thick broth. The dumplings are swollen pieces of dough that are so filling it seems silly to eat the biscuit that comes with the order. This is what I want on a cold, wet day to warm me up from the inside out.

Everything about Kathy & Joe's Place seems to have the chicken-and-dumplings warming effect. The couple at the helm of this diner lives and serves by the Golden Rule. Even if you walk in and roll your eyes at the Pinterest-ready encouragements looming over your table, you can't help but feel a little more cheerful after Joe refills your drink and beams when you tell him how much you enjoyed your food. And when you settle your ticket with Kathy at the register, a woman who always wears a smile and a hairnet, it's hard not to walk away with a smile of your own.

DISHING WITH STEVE COOMES

Food writer

Steve Coomes has done a little bit of everything when it comes to working in restaurants. His background in the kitchen lends itself well to his current profession as a food writer. Steve is the author of *Country Ham: A Southern Tradition of Hogs, Salt & Smoke* (The History Press). Much of his writing focuses on fine dining, but Steve appreciates a good diner and the people who work there.

Ashlee: *What is your definition of a diner?*
Steve: My definition of a diner is [a place that] serves breakfast around the clock. The menu never changes. You can get anything on the menu, sometimes, if not twenty-four hours a day, extended hours. It's affordable. It's fast but not rushed. It's very casual, but it's not casual like fast food. You put decent clothes on to go to a diner. I don't show up in a wife-beater and shorts. It's still going out to eat. Somebody's going to wait on you in most places. Perhaps, naïvely, idealistically, a diner has a character. You can watch people cook, which I love. Service isn't fake or overly friendly. Sometimes, it's not friendly at all. But it's within context. It's the tired waitress. It's the grizzled cook. They're just cranking it out, and you expect that. But

it's always great, it's always within your budget and it's something that you crave. I love Seviche as much as anybody, but I don't wake up craving it. Really good meatloaf? Yeah, that sounds great right now.

Ashlee: Can you talk a little bit about the admiration chefs have for diner cooks?
Steve: Absolutely. When I waited tables, breakfast could be the trickiest shift because it's the first meal of the day. People have not typically had anything to eat for eight hours. They could be grumpy, and they like breakfast their way. It's one thing to say, "I like a steak medium rare." But how you get it, they don't care. But by golly, my eggs, whether they want it over easy or runny or firm, that's the way they want it. People will eat a well-done steak even if they ordered it medium, but what they'll send back is a three-dollar order of eggs like they've tapped the wrath of God. They're just particular about their eggs. So these guys and gals that cook and serve, they've got to get it right. There's very little grace in the morning. So their ability to track all of that, and organize it, that kind of mental acuity, people underestimate.

I'm no dimwit, but I'm no genius either, so I had to work as a chef at memorizing quite a bit when it came to detailed ordering. But the nice thing about fine dining for me was ordering things that are different, different, different…Then there's eggs, eggs, eggs, eggs, eggs, but every one of those dishes has some nuance. "That was eggs over what? Scrambled? Fried? What?" It's all shades of gray, and they have to remember it on the fly. I found that really hard for me. And I think most chefs do. There isn't one chef I've ever met that isn't thrilled to watch a good breakfast cook in action. That's kind of the beauty of a diner—you get to see that guy or gal work. Any person that's never done that job and sees a person doing it doesn't get how hard it is by watching them.

Ashlee: Where do diners fit into our city's food landscape?
Steve: That's a great question because I haven't thought of an answer. I don't think the answer is so profound. I know the answer isn't that they don't have a place just because of what's going on in NuLu or what's going on Bardstown Road. That would be foolish to think that they don't have a place. The way that I look at it, statistically, I think I would be correct, is that only about 20 percent of the dining populace in this city goes to those trendy, somewhat exotic, expensive, special-occasion places; 80 percent of the rest of the people go to chain restaurants and simpler restaurants. It's just the 20 percent get all the attention. People see that food as art, food that's entertainment. A diner is a place for sustenance. So, how many people go

out for sustenance versus entertainment? I think there's always going to be a majority of the population that goes out for sustenance. There's no debating that. And so I think that when you present an experience that somebody you know finds satisfying both with their mouths and their souls and with their mood, you're always going to have a great concept. And diners are successful at pulling that off. They're always going to have a place.

THE SOUL

West End/Shively/Smoketown

Brace yourselves. I'm about to discuss race relations in America. It'll all make sense. Trust me.

Let's remove the sometimes-hazy lens of nostalgia for a moment and take a clear look at the heyday of the American diner. In the 1950s and 1960s, diners became destinations for an expanding middle class with disposable income. Those glory days coincided with the enforcement of racial segregation in large segments of the country. White diner owners turned away a sizeable pool of potential customers because of segregation laws or heavy social and cultural pressure where such laws were absent.

When I started doing research for this book, I found that the era's racial inequality left an absence of information about the experiences of African Americans and other people of color in diners (with the exception of passages about the civil rights movement—more on that later). I was disheartened that the contributions of African Americans like me were missing from the news clips and history books. My reading left me with one big question: If white-owned diners were hostile places for black people to patronize, where did African Americans go for comforting meals?

After some thinking and even more research, I figured out a few things:

- The soul food restaurant was the answer to separate and unequal treatment that black people received in white-run diners.
- Segregation and its eventual end are an essential part of American diner history. Although many sit-ins and protests of the civil

rights era focused on national lunch counter chains, the results of the movement brought the diner experience within reach to all Americans, regardless of color, and gave the country more exposure to African American cuisine.

- Soul food in Louisville reaches all races with its unique flavor of family, tradition and basic recipes.

A complicated combination of ethnicity, race and class shaped American diners after World War II. Diners had become a mealtime destination for the country's growing middle class, a group that was more diverse than it had ever been. More ethnic and racial minorities had gained access to unionized industrial and white-collar jobs. These positions paid enough to cover the necessities and left pocket money for leisure activities like eating out. The changing middle class presented what was at the time a difficult question for white diner owners: Should they serve whites *and* blacks at their counters and booths?

Jim Crow answered that question for many businesspeople. These laws, which states in the South imposed after Reconstruction ended in 1877, enforced racial segregation in public places like schools, public transportation and restaurants. Diners in the land of Jim Crow served black people separately and unequally (if they were even served at all). Some restaurants had a "colored" window at the rear of the building where blacks could buy their meal to take and eat elsewhere. Even African American cooks at these diners had to eat their food tucked away from the eyes of white customers, as author Frederick Douglass Opie noted in the book *Hog and Hominy: Soul Food from Africa to America.*

Outside the South, diner operators were afraid of losing white customers if they accepted black patrons. Many owners enforced racial restrictions and mistreatment similar to Jim Crow, as Hurley explained in *Diners, Bowling Alleys, and Trailer Parks.* Some diner operators in midwestern and northeastern cities subjected black customers to spoiled food, bad service and inflated prices to discourage them from patronizing these restaurants. Geography also helped reinforce racial divisions for diners in white suburbs. Black people implicitly understood that they wouldn't be welcome in these areas, so they stayed away, according to Hurley.

Folks who couldn't sit at the counter turned to the soul food kitchens of their neighborhoods. Most black communities had at least one restaurant or cafeteria that served a style of food that would later be called "soul food." These businesses operated "behind unassuming storefronts and in crudely constructed free-standing buildings," Hurley wrote, a result of the increased

difficulty black entrepreneurs had in getting loans to move into structures more similar to mainstream diners.

Soul food existed long before segregation, but the Jim Crow era created a new type of consumer demand: a desire to be treated respectfully. In soul food restaurants, African Americans could enjoy a meal with dignity. These

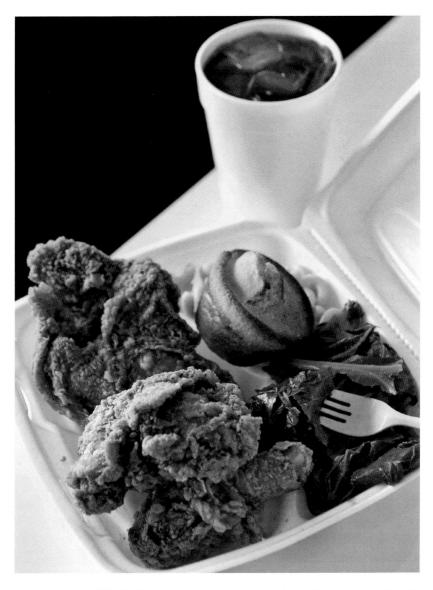

A takeout order of fried chicken, collard greens, macaroni and cheese, cornbread and iced tea from Franco's Restaurant and Catering. *Photo by Jessica Ebelhar.*

restaurants provided the same feeling of homecoming and warmth that white customers found in diners.

"Jim Crow policies ensured that black restaurants remained separate black spaces," Opie wrote. "For working-class blacks, these eateries enabled them to relax and recover from the stress of racial politics in North America."

From the 1930s through the 1950s, black-owned restaurants popularized southern fare that had typically been reserved for special occasions, such as fried chicken, fish sandwiches, chopped barbecue, biscuits, sweet potato pies, cakes and collared greens, Opie noted. "It was food that was easy to market, because it was relatively inexpensive, it tasted good, and it was attached to memories of special times spent with family and friends in tight-knit African American communities."

African American food began to come into focus for much of the country during the civil rights movement. Food was often at the center of protest planning, whether it was in a church, at a black restaurant or around the kitchen table. For many white protestors from the North, these meals were their first exposures to African American cuisine. They would later return home and search for similar dishes in their own cities, wrote Jessica B. Harris in *High on the Hog: A Culinary Journey from Africa to America*. This cultural exchange helped bring African American dishes into the mainstream.

It was the food of the white American middle class that protestors targeted in the sit-ins and boycotts of the civil rights movement. It's no coincidence that protestors chose to highlight food service (or lack thereof) as the subject of their peaceful protests at lunch counters. Lunch counters, like the diner, had become hallmarks of American middle-class dining. Protestors knew that they could draw the nation's attention to racial injustice by illustrating the indignities served at the counters. Rather than focus their energy solely on mom and pop diners, protesters targeted southern lunch counters in national retailers such as Woolworth's for sit-ins. Larger chains were more likely to feel pressure on a national scale when customers from across the country boycotted in solidarity with southern demonstrators. "Food became a metaphor for society," Harris wrote.

The civil rights era cross-pollinated America's plate. Black people won a place at the counter, and African American cuisine gained recognition outside the black community. "Black food in its increasing diversity was no longer segregated on the blacks-only side of the menu," Harris noted, "but squarely placed on the American table."

The term "soul food" came into wide use during the civil rights movement. For many blacks in America, this era marked the first time that

peers encouraged and accepted showing pride in the African American experience. "Soul" was a lofty adjective that established community and denoted kinship in the African American struggle.

The definition of soul food changes depending on whom you ask. For me, soul food is a rich meal made from a poor man's scraps. It is Sunday dinner at my mom's house. It is pork fat and greens, beans and cornbread, fried chicken and hot sauce. It is food born after years of struggle and bound together with improvisation and hope. I also like the list of traits Opie created in *Hog and Hominy*. According to the author, soul food is, among other things:

- *an art form that comes from immersion in a black community*
- *an intimate relationship with the Southern experience*
- *a blend of many cooking traditions that Africans across the Americas seasoned to their own definition of perfection*
- *simple food that is often complex in its preparation*
- *nitty-gritty food that tasted good and helped African Americans survive during difficult times*

Soul food has evolved since its peak of popularity in the 1970s. Activists, community leaders, physicians and other members of the black community have encouraged healthier alternatives to the traditional staples of a soul food diet, such as fried foods and a reliance on pork. But this style of food, with such strong ties to history, struggle and celebration, will always be an integral part of American dining.

Soul food in Louisville draws followers of all races eager for meals that delight the senses. Like their segregation-era predecessors, Louisville's soul food restaurants are mostly located in the city's predominantly black neighborhoods, such as the West End and Smoketown. Many of Louisville's soul food proprietors began cooking out of necessity rather than passion. They cooked meals for younger siblings when their parents went to work. They cooked for their own kids when they needed to save a little money. The artistry behind preparing a meal isn't what appeals to these cooks. They keep cooking because they love how happy their food makes customers feel.

BIG MOMMA'S SOUL FOOD KITCHEN

4532 West Broadway
Louisville, Kentucky 40211
502-772-9580

Sneeze and you'll miss Big Momma's Soul Food Kitchen. First, you have Shawnee Park. It's easy to get caught up in the beauty of a big stretch of green space at the end of Broadway and miss Big Momma's, which is right across the street from the park. Then, you have some confusing signage. The lettering from the previous tenant, Park Side Café, is still visible on the cloth awning above the door. But stay focused. You came for something fried or smothered. You came for vegetables seasoned with so much meat that you're not sure if you're really eating a vegetable. You came for soul food.

Big Momma's is located in the West End, a predominantly African American area of Louisville with nearly 150 years of history. Former slaves who migrated to Louisville after the Civil War created communities in different pockets of the city, such as Smoketown to the east and California and Little Parkland (sometimes called Little Africa) in the West End. However, African Americans were restricted to these neighborhoods even as the population blossomed into the late 1800s, according to the *Encyclopedia of Louisville.* In response to the growing number of African Americans, the Louisville City Council and the Louisville Board of Aldermen passed an ordinance in 1914 that prohibited black people from buying property on blocks where white people lived and vice versa. The case eventually made its way to the U.S. Supreme Court. The high court, which at the time included Louisvillian Louis D. Brandeis, ruled unanimously on November 5, 1917, that the housing segregation law was unconstitutional because it interfered with a person's property rights, not because of racial discrimination. Although the block-by-block segregation was struck down, white people who lived in the neighborhoods of the West End continued to trickle out of the region. After the Great Flood of 1937, white people with the means to do so left the West End in droves to areas on higher ground, such as the Highlands, the *Courier-Journal* reported.

Big Momma's Soul Food Kitchen resembles Jim Crow—era African American restaurants—small interior, soul food menu and a largely carryout operation. This is a kitchen in the best sense of the word—the most magical room of any home, where produce and spices and raw meat mingle and become hearty cuisine.

A fall afternoon in the West End. *Photo by Kelly Grether.*

Signs posted around the tight ordering area list the menu, which changes daily. You can expect a selection of entrées, a handful of sides and a couple desserts each day. Staff rotates fresh food in and out of silver serving trays you might recognize from a cafeteria or buffet. The chicken tray brims with a jumble of wings, legs, thighs and breasts warming under a bright lamp. Slices of meatloaf marinate in thick, red sauce. Brown gravy smothers a pan of pork chops.

There's no room for frills at Big Momma's. There's a counter with about a half dozen stools pushed against a wall. The food is the centerpiece of the waiting area, where it waits behind the thick plastic partition. Between this tempting view and the entrance, there's just enough space to accommodate the dinner rush. When it's time to order, I crane my neck to speak into one of the two microphones that jut from the wall. The total cost of your order is a bit of a mystery unless you ask first, and that might draw the ire of the folks waiting behind you. The after-work crowd is trying to get a meal on the way home from work. Plus, there's not enough room to dawdle.

Big Momma's operates under the assumption that customers will take their food to go, so the crew packs every meal into sectioned Styrofoam boxes. I eventually find out that dinners with two sides are $8.50, and fish dinners are $9.00. My teeth sink into the meat of the fried chicken, still warm after a nap under the heating light and a twenty-minute car ride home. The well-seasoned skin is still crisp. Corn kernels dot my green beans, as do a few pieces of fat. For the more health conscious, the baked chicken is just as good as the fried option. It's moist, juicy and seasoned with a sprinkle

of paprika. Vegetarians have to bend a little if you want to take a trip to Big Momma's. Some kind of pork fat has mingled and marinated with most of the vegetables. An order of cabbage has loads of shredded pork, tender from what must be hours of time in a pot cooking low and slow.

The Big Momma behind all of this soul food is Jessie Green, a cook who reluctantly found her calling. She often helped in the kitchen when her church, King Solomon Missionary Baptist Church, hosted programs and provided meals. People took to her cooking, so she began to sell dinners out of the church kitchen. Soon, her operation outgrew King Solomon, and she moved into the West Broadway space in 2004. "My mother was a cook. I don't really like cooking," Jessie says. "I saw that people enjoyed it, so I kept on doing it."

Jessie's spirit of giving back infects everything she does, from the taste of her food to the charity she provides. Big Momma's hosts an annual free Christmas dinner for anyone who wants or needs a meal. Last year's event brought upward of eight hundred people to the restaurant, Jessie says. And if someone comes into Big Momma's hungry but empty-handed, Jessie will provide a meal and give him or her a little work to do. "You never know when you are going to be down," Jessie says. She was one of thirteen siblings, and people helped her family when they could. Jessie continues to pay forward the kindness she received in her childhood. "You help anybody you can."

Jessie puts the same care into her food as she does her customers. She's at Big Momma's every day at 6:45 a.m. to begin meal prep with her family, many of whom work at the restaurant. I catch her one weekday morning in the middle of a lengthy to-do list. She still had to fry pork chops, cook her beans, mix the cornbread and prepare the macaroni. She had already put her oxtails on the stove to cook, and she was in the middle of slicing her roast beef.

The long hours working on the concrete floor of Big Momma's have started to wear on Jessie. She had to get a plate inserted in one of the arches of her feet. But this seventy-year-old can hang with the best of them. "I don't want to retire. I want to be in here. I'll probably die in here," Jessie says. "I like being around family. I like to keep moving. God willing, I'm going to stay here as long as I can."

FRANCO'S RESTAURANT AND CATERING

3300 Dixie Highway
Louisville, Kentucky 40216
502-448-8044

It's the tail end of a weekday lunch hour at Franco's Restaurant and Catering, and the lunchtime fraternity is just getting started. About half a dozen older men have claimed the restaurant's largest table, the circular one right between the food line and the front door. Their plates are still full of fried entrées and colorful sides; good conversation leaves little time for eating. Eventually, they'll swoop their forks down for some greens or a bite of catfish, but right now, it's time to talk. Their loud, deep voices and throaty laughter eclipse the soft jazz that is the intended soundtrack for the midday meal. They don't seem to notice. Other customers don't seem to care.

I find Frank Foster seated at this table, the quietest member of this seasoned bunch. At first glance, the chatter seems to have lulled the seventy-two-year-old into the twilight between awake and sleep. Don't let the calm throw you off. "People see you sitting and talking," Frank says. "They don't know you're watching."

Technically, Frank's son, Domanic, is in charge of Franco's. But Frank, who's been in the restaurant industry for four decades, still has a lot of

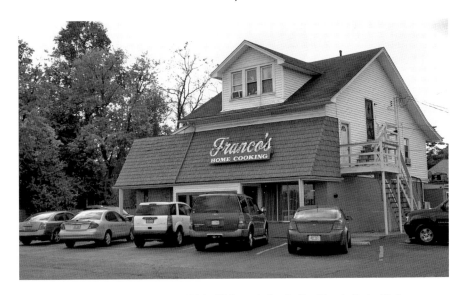

Franco's Restaurant and Catering on Dixie Highway in Louisville. *Photo by Jessica Ebelhar.*

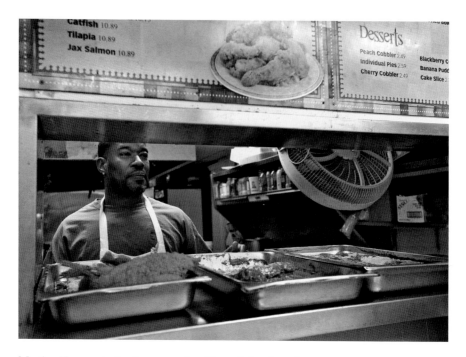

Martino Young, who has been a cook at Franco's for about five years, serves up orders at the restaurant. *Photo by Jessica Ebelhar.*

teaching to do. "It's gonna be him one day, so he needs to get on the ball," Frank says.

Franco's is located on Dixie Highway in Shively, but it's a descendant of a West End enterprise and longtime Louisville favorite called Jay's Cafeteria. Frank opened Jay's in 1974 at Eighteenth Street and Muhammad Ali Boulevard. The restaurant drew residents from the surrounding neighborhoods, and it was close enough to downtown to attract businesspeople with a craving for a more soulful, filling meal than a soup and sandwich. Jay's faced some hard times in the 1980s, when nearby businesses shuttered and cut off what had become a reliable customer stream.

But Jay's bounced back, and the restaurant had become a neighborhood success story by the end of the decade. Annual sales reached nearly $1 million in 1990, Frank told the *Courier-Journal* in 1991. The dining room saw five to six hundred people per day in 1992. And in 1993, Frank broke ground on a $1.6 million, thirteen-thousand-square-foot expansion that then Louisville mayor Jerry Abramson lauded as a dream come true for the neighborhood, according to the *Courier-Journal*.

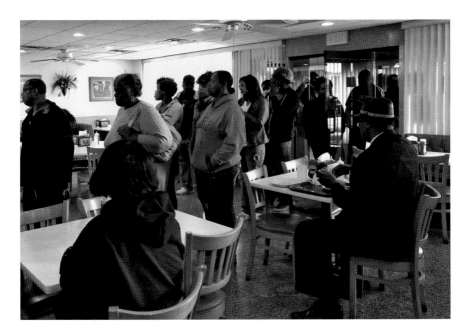

The line of customers extends out the door at Franco's. *Photo by Jessica Ebelhar.*

A little more than a decade later, the fanfare faded. Jay's was auctioned off in bankruptcy proceedings in 2005, the *Courier-Journal* reported.

Frank toyed with retirement after Jay's Cafeteria closed, but "it was too boring," he says. "My mind is so strong. I'm not ready for the rocking chair. When I get up in the morning, I'm ready to go." Frank was prepared to help when his son, Domanic Foster, decided to dive into the restaurant industry. After a few attempts at different locations, the Fosters settled into a white building with a bright red roof in 2008.

The interior commands a certain respect from customers that the staff reciprocates. A sign on the door warns visitors that sagging pants are not allowed inside. The décor is a little 1980s—lots of dark salmon and turquoise that extend to the trays that hold your food. Sconces are filled with plastic lilies for a perennial cheer that will accompany meals to come. The walls are filled with pictures of Frank smiling with local and national celebrities who once graced the doors of Jay's.

You can find Frank in the dining room just about every day. He can't stay away from the food, the people and the community. "I've had a lot of trades, but restaurants are in my blood," he says.

Frank's role is similar to that of a choreographer. He has spent most of his time teaching the Franco's crew a routine. When the doors open, he sits at

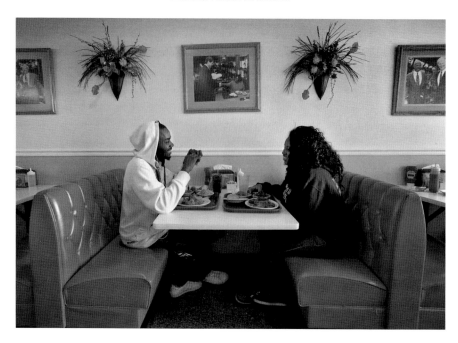

Brian Gordon (left) and Rob-Nesha Felton chat during lunch at Franco's. *Photo by Jessica Ebelhar.*

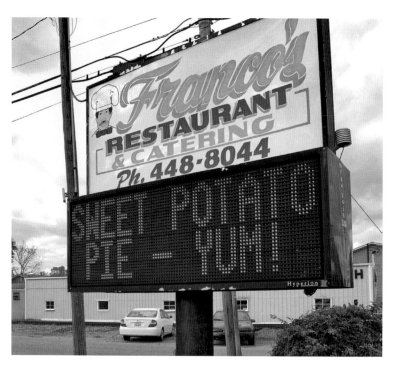

Franco's displays one of the restaurant's desserts. *Photo by Jessica Ebelhar.*

the big table and watches his students perform. A bad back keeps him seated, so Frank does as much as he can from the sidelines. In the course of our interview, he answers two phone calls, helps his granddaughter fiddle with a smartphone, orders a refill on his orange soda and directs an employee to change the warming lamp's bulbs above the chicken and fish. He doesn't yell. In fact, Frank's quiet drawl sometimes makes it hard to make out what he's saying. His employees hear Frank loud and clear. "I preach to my people that people buy with their eyes," Frank says. "All the food is there for you to see. You'll buy a lot more on impulse if it looks good."

The mention of Frank Foster still draws admiration from fellow restaurateurs. "He took food service to a higher level than anyone," says Shirley Mae Beard, owner of Shirley Mae's Café and Bar in the Smoketown neighborhood. "I would say he's the soul father of black food service."

Franco's borrowed the cafeteria-style dining from Jay's. Folks behind the plastic partition scoop sides and sift through chicken pieces. A gloved employee places the entrée (it's usually a meat, so vegetarians be warned) on a plate, scoops side dishes into little bowls and slides each dish over the top of the plastic sneeze guard. Customers place these plates and bowls on trays grabbed at the beginning of the line. The only problem with the cafeteria spread is the need to make a decision and stick with it, which is a difficult proposition when there are so many options. Before one visit, I had my heart set on a nice piece of catfish, one of Franco's favorites ($10.89 for a catfish

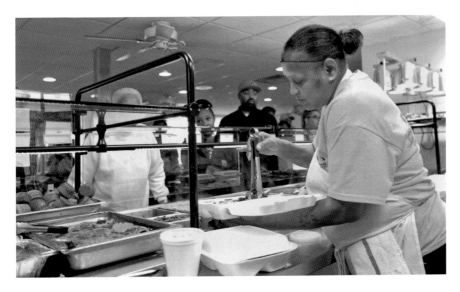

Franco's employee Theresa Beamus fulfills an order. *Photo by Jessica Ebelhar.*

Employee Theresa Beamus prepares a customer's to-go order at Franco's. *Photo by Jessica Ebelhar.*

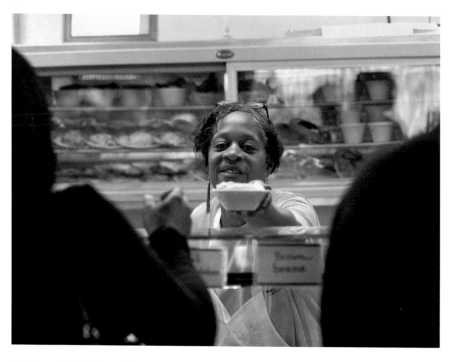

Employee Patricia Arnold serves a customer at Franco's. *Photo by Jessica Ebelhar.*

An employee grabs a pan of fresh cornbread at Franco's restaurant. *Photo by Jessica Ebelhar.*

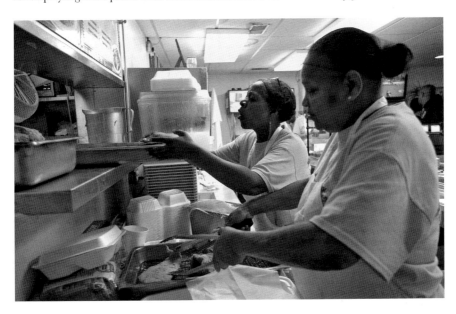

Employees Patricia Arnold (left) and Theresa Beamus fulfill orders during a busy afternoon at Franco's. *Photo by Jessica Ebelhar.*

dinner with two sides). Then I got in line and came eye to eye with a pile of golden brown fried chicken fresh from the fryer. I had a sudden craving for poultry and a change of heart.

This chicken is worthy of changing your mind. Not too much salt, not too much pepper. The crisp breading leaves just a hint of grease on my fingertips. The sides are also worthy of equal praise. Turnip greens still have enough crunch to feel like you're eating (somewhat) healthfully. I ask for a few rings of raw onion plucked from the silver tin at the end of the line, which add a nice bite to the greens. The yams are sweet enough that they could be counted as dessert. Hunks of them swim in a syrupy bath of brown sugar and warm spices. But the price for this two-piece dinner with two sides ($8.89) was even sweeter.

Some folks might miss Jay's, but Franco's fits the Louisville restaurant scene nicely. The dishes at Franco's are just as good as those of its predecessor, if not better. Enough customers come through the doors to keep plenty of hot food rolling from the kitchen to the meal line. Yet Franco's is small enough for a table full of gentlemen to take up residence for an afternoon without feeling rushed out the door.

SHIRLEY MAE'S CAFÉ AND BAR

802 South Clay Street
Louisville, Kentucky 40203
502-589-5295
http://shirleymaescafe.com

Food prep is a three-day undertaking at Shirley Mae's Café and Bar. The restaurant is closed Monday, Tuesday and Wednesday because of all the greens to wash, chitlins to clean, corn to shuck, potatoes to peel, onions to slice, sweet tea to brew and jam cakes to bake. And that's just the beginning.

Shirley Mae Beard is diligent about sticking to simple, old-fashioned cooking. Her methods are time-consuming but basic by her own definition. There's no other way to cook for Shirley. She likes things her way. The beef for her meatloaf needs to be ground in-store, not prepackaged—Shirley swears she can taste the difference. Don't get her started about preservatives in food. She doesn't use any canned goods in her dishes, thankyouverymuch. Everything from Shirley's kitchen is fresh, just the way she likes it. "That's what turns me on," Shirley says.

Shirley has earned the right to be particular about the food she serves at her eponymous café. Shirley Mae's has been a cornerstone of the

Smoketown neighborhood and a hub of civic activity for more than twenty years. Shirley Mae's operates at a steady pace even though it's open only four days a week. The restaurant's repeat customers, who range from downtown businesspeople to Smoketown neighbors, keep this place pumping.

"My food has its own taste, and we have people that acquire that taste," Shirley says. "Once you start eating the real food, you have a hunger for it."

I can testify to the power this woman wields in the kitchen. Shirley's meatloaf ($4.00 to $10.00, depending on how many sides you get) takes me across town to my mother's kitchen table in Shively. Shirley cooks the beef in a tomato sauce rather than adding a dreadful squirt of ketchup on top of the meatloaf. Cooking the meat in the sauce results in a more flavorful, moist dish that brims with tomato flavor and spices. This is the kind of meatloaf I crave when I want a home-cooked meal from my mom. I'd never had anything that came close until I visited Shirley Mae's.

The food that doesn't tap into my sentimental side is also deserving of recognition. Shirley shows the ribs ($6.00 to $12.00) as much love as the meatloaf; I can only imagine the hours these slabs spend on a grill. The sides are made from scratch, and it shows in a good way (I'm looking at you, lumpy mashed potatoes).

Shirley's way of cooking has attracted plenty of folks to Smoketown, a neighborhood bounded by Preston, Caldwell, Jacob and Shelby Streets in an area that's southeast of downtown Louisville. The history of this neighborhood begins in the 1800s, when Quakers were the first people to settle in the area. Residents of German descent became the dominant cultural group in the late 1800s, according to the National Register of Historic Places. In the 1860s, an influx of African Americans arrived in Smoketown because of a belief that the abolitionist General John Palmer, commander of the Union forces in Louisville, would emancipate all African Americans present in Louisville on July 4, 1865. Even after the rumor turned out to be false, black people continued to migrate to the area. Smoketown is considered the largest continuously occupied African American community in Louisville.

The city has recently turned its gaze upon Smoketown. In 2013, the grassroots organization Kentuckians for the Commonwealth moved its Jefferson County office into the neighborhood and completed a community-wide canvassing project to gauge the needs of Smoketown. The housing projects that were located in the neighborhood have been torn down to make way for mixed-income housing.

Shirley embraces the history, pride and African American heritage of the neighborhood. Since 1989, the restaurant has hosted the annual Salute to

Black Jockeys, an event that commemorates the African American jockeys who have ridden winners of the Kentucky Derby. The restaurant has even become a campaign stop for the candidates and politicians Shirley supports, such as 2014 U.S. Senate candidate Alison Lundergan Grimes, Louisville mayor Greg Fisher and U.S. Representative John Yarmuth. Election Day had been over for a few days when I talk to Shirley, and she says there are still about five hundred Grimes signs that her family put up around the neighborhood (Grimes lost to incumbent senator Mitch McConnell). "We're a low-key people," Shirley says. "But if it's somebody we support, we go all out."

The exterior of Shirley Mae's is equally low profile. The building that houses Shirley Mae's is pushing 130 years old. Before Shirley bought the building in 1988, it had multiple reincarnations, including a private residence, a grocery store, a dry goods store and a food bar, according to the Shirley Mae's website.

On the outside, Shirley Mae's looks more "bar" than "café," mainly because of the folks seated outside drinking beers during my first visit. Inside, a large bar takes up most of the narrow interior space, and there are a few empty tables against the wall. During one visit, a rerun of *The Closer* airs on a flat-screen TV at one end of the room. The action is on the sidewalk, where smooth jazz and R&B provide a backdrop for the patrons outside.

I hope the people outside eventually order some food, as the real party is served on plates, not in bottles, at Shirley Mae's. The down-home cooking here is powerful enough to evoke comfort in the most unexpected of settings. The restaurant might not look like much, but the spirit is packed into what comes out of the kitchen. Some Shirley Mae favorites include the three-dollar pinto beans ("these are the pinto bean-iest folks I've ever met in my whole life," Shirley says of her customers) and two-for-one-dollar hot-water cornbread ("they eat that like cookies").

Shirley has spotted chefs from higher-end Louisville restaurants at her place. They order a hodgepodge of dishes from their seat at the bar and try to get a peak at what's going on in the open kitchen, Shirley says. But if they really want to cook like her, "they'd have to hire thirty more people," she says.

Shirley knows her food is good, but she doesn't overthink the creative process. She scoffs when you mention recipes. She insists that she sticks to just salt, pepper and butter when it comes to seasoning. "It's basic," Shirley says. "It's based on logic."

At eighty years old, Shirley is still nimble around the kitchen (her daughter, Dee, mentions her age, but Shirley refuses to confirm it). She cusses and

smokes and admits to having little patience for teaching others how to cook the old-fashioned way. But when I tell Shirley how much I enjoy her meatloaf, a smile spreads across her face. "Having this business is more than I could've dreamed of," she says. "I'm grateful for this opportunity to make things people enjoy."

DISHING WITH KEVIN GIBSON

Food and beverage writer

Is a taqueria a diner? Kevin Gibson thinks so. The Louisville-based food and beverage writer has an inclusive view of what kind of restaurant earns the "diner" label. Kevin recently published *Louisville Beer: Derby City History on Draft* (The History Press). His expertise might be beer, but Kevin knows his way around Louisville diners.

Ashlee: *How do you define a diner?*
Kevin: To me, a diner has three key components. One is accessible, familiar comfort food. Another is inviting, cozy atmosphere. And the third is reasonable price points.

Ashlee: *What makes diners special in Louisville?*
Kevin: Historically, when you think about a diner, you think about Monk's on *Seinfeld* or one of those from the '40s or '50s that was cookie cutter, that was a prefab trailer. You think of maybe a 1950s movie where they're sitting at a booth in a diner or sitting on stools, and you've got a guy in a little white hat who's serving them milkshakes and burgers.

But to me, the way Louisville has evolved (and other markets are the same) is that what a diner is has expanded…

Restaurants, well, everything in society, is becoming more and more specialized than it was fifty years ago. Restaurants are the same. I feel like many things you would've never thought of as a diner can sort of be lumped into that. And I think it's a great thing because it gives you more options. Barbara Lee's Kitchen? Absolutely a diner. No arguments about that. It's a diner. Twig and Leaf, you have to argue that that's a diner, probably one of the better-known ones in Louisville. I could argue, maybe unsuccessfully, but I could argue a place like El Molcajete down

by Churchill Downs is an ethnic diner. Small, inviting atmosphere, low price points and it's filling comfort food. It just happens to be a different type of cuisine. There's a Salvadoran restaurant in the South End that I went to with my girlfriend, and we had a full meal, and we sat and chatted, and it was cozy, and I think we paid eleven dollars for all of it and had food to take home. It just wasn't scrambled eggs and biscuits and gravy. It was something else…

This is what I love about Louisville, unlike Memphis, which is known for its barbecue, or New Orleans, which is known for its seafood or whatever. Louisville's got a big melting pot of food on so many levels, from the five-star restaurants to the diners.

Ashlee: *Do you find that people are still willing to drive outside of their neighborhoods to try these little hole-in-the-wall places?*
Kevin: My impression is that certain diners that have been around for a while have their regulars. Barbara Lee's, people have been going there for twenty years. And places like Highland Morning are building a neighborhood set of regulars. But trying to reach just outside the box to get people to hear about it and come down? I definitely think there's potential for that.

Ashlee: *What are some diners you like to visit?*
Kevin: I love taquerias. A taqueria to me is a Mexican diner.

Ashlee: *Is it the food or feelings that people like the most about diners?*
Kevin: Most people are there for the atmosphere. Like I said, if you think about Monk's from *Seinfeld* or you think about those clichés from *Back to the Future*, people love that. I do, too. It's nostalgic.

Ashlee: *Why do you think people seek out nostalgia?*
Kevin: I think it's the same way that an old song that you heard in your parents' station wagon in the '70s or the '80s becomes part of your life, becomes something meaningful, and you attach it to emotions. Food does the same thing. And I think that in a lot of cases, a diner like that and the food can bring back those sorts of memories. Sometimes it's tactile. Sometimes it's emotional. But it harkens to something that you hold dear, like an old toy. Think about it. When you see an old toy you had when you were eight, and you've been to a flea market and see one, it evokes emotion. Diners have that power.

Ashlee: *Where do you see Louisville diners going?*

Kevin: I think the trend will continue toward some level of specialization. Wild Eggs has sort of done that. People seem to really be into omelets. There seems to be a big brunch movement. You see a lot of Bloody Mary bars and mimosa specials and things like that on Sundays…I can see that taking hold in diners and kind of expanding those boundaries a little more.

My hope is the food won't change. I'm OK with it expanding a little, but sometimes you just want biscuits and gravy or a couple of fried eggs you can dump your toast in. Sometimes, you've just got to go back to that and leave the arugula off of it. You don't need sun-dried tomatoes in your omelet every time. Sometimes, you just need cheese and bacon and eggs. My hope is that it will still expand a little bit, but we'll never lose the core of what makes a diner what it has been and should be, which is the most comfortable food at the lowest price point in a place that you want to come back to.

Part IV

THE FUTURE

Crescent Hill/Highlands/East End

My iPhone has become my favorite utensil when I dine out. Before I take a bite, I snap pictures for Instagram, cross-post to Twitter and Facebook and maybe tweet out the menu. Once I do dig into my plate, I'm eager to try modern twists on diner favorites, like candied bacon or pancakes topped with mascarpone. In short, I'm a millennial.

My birth year makes me part of one of the most studied and prodded generations of Americans since the baby boomers. We're a group of 80 million young people born roughly between 1978 and 2000, according to the *Washington Post.* We're sitting ducks for restaurants (diners included) that want to tap into our expansive buying power.

Millennials are a tricky, contradictory group when it comes to eating out. We want to be fed and entertained and impressed. We want food to be authentic, but we're fine with fusion. We call ourselves "foodies," but we'll swing through a drive-thru. We want dining to be a communal experience, even if we look at our phones during the entire meal. And we don't just want a meal; we want an experience. Millennials are equal parts fascinating and exhausting.

"Millennials…from what I understand about reading about them and marketing to them, is that they are more concerned than past generations have been with local," says Kevin Gibson, a Louisville-based food and beverage writer. "They're more concerned with giving back to society. There's more of a social consciousness and awareness that can only bode well for a traditional diner. These are the twenty-three-year-olds or twenty-

four-year-olds that will walk to the corner diner and patronize it because they feel a duty to do so."

The quirks of my generation have affected the modern American restaurant industry, including the humble diner. Louisville's newest diners have to give an increasingly sophisticated and tech-savvy audience unexpected flavors and authentic down-home charm, tall orders for such a modest type of restaurant. These modern spins on old-school food pique the interests of millennials but satisfy palates of all generations.

It's no coincidence that many of the youngest diners are located in the saturated restaurant rows of Louisville such as the Highlands, Frankfort Avenue and the East End. In these neighborhoods, customers expect more options in their dining experience—gluten-free, low-carb, no-carb, Paleo, local, organic, grass-fed, free-range, vegetarian, vegan and allergen-free. Discerning patrons encourage and expect something new and different when they go out to eat in these high-profile dining areas. They expect nothing less from diners.

Chefs, not cooks, are at the helms of the griddles at Louisville's newest diners. They embrace diner food while they tinker with tradition. Breakfast, perhaps the most popular meal in a diner, is the main subject of these chefs' experimentation. They repackage early-morning dishes to satisfy crowds that love a quirky meal before work or a decadent weekend brunch. "You can get a big stack of pancakes. You just might have a lot of fruit with it and with some interesting toppings on it," Gibson says.

No meal is safe from modernization in these new diners, and this fearless attitude helps these new diners get the attention they deserve. SuperChef's Breakfast and More coats its French toast in granola. Wild Eggs makes its biscuits and gravy with chorizo instead of plain sausage. Highland Morning has a banana liqueur sauce that comes with the Foster Your Waffle dish. These restaurants might be a little more upscale, Gibson says, but "if I want scrambled eggs and toast and bacon, I can get it. And it's still not going to cost more than seven or eight bucks."

Contemporary diners adopt the twenty-first-century notion that a meal is an experience that goes beyond the palate and plate. Social media has allowed our digital friends and followers to experience each meal right along with us. So, diners are upgrading their online presence, their menus and their presentation to catch up to the ever-connected millennials. Diner operators post hours of operations and daily specials on Facebook and Twitter pages. You can interact with other customers about their experiences at a particular diner. If you have a bone to pick, you're just an e-mail away from the owner.

Executive chef Trevor Semones prepares an order of Strawberry Tall Cakes at Wild Eggs in downtown Louisville. *Photo by Jessica Ebelhar.*

Some diners will never change their traditional offerings and operations, and we wouldn't want them to. We all have a soft spot for the old-school diner that won't even give turkey bacon a chance. Classic diners provide a much-needed rest from our world of twenty-four-hour accessibility, when we've gotten a little too caught up with what Instagram filter to use on our shrimp and grits photo or when the glow of a smartphone prevents us from truly enjoying our meals. And sometimes, you just want some really cheap bacon and eggs.

That being said, I am a millennial. I won't stay away from my phone for too long. And I like a meal that will take me on an edible adventure. There's a time and place to have a little fancy with my diner meal—as long as there are a few rough edges, too.

EGGS OVER FRANKFORT

2712 Frankfort Avenue
Louisville, Kentucky 40206
502-709-4452
Facebook: https://www.facebook.com/pages/Eggs-Over-
 Frankfort/244084622456122
Instagram User Name: eggsoverfrankfort

It's easy to find Eggs Over Frankfort—just look for the long line. Clusters of young people and families review menus as they lean against closed storefronts and wait for a seat at this Frankfort Avenue diner. It's the early Sunday afternoon brunch rush, an event that has become a mandatory weekend activity for the young and hip in Louisville. Eggs Over Frankfort is open for only three hours on this day, and folks are itching for a seat.

Eggs Over Frankfort has only been open since summer 2014, but the restaurant has become a hot spot in Crescent Hill. The restaurant blends the mellow, quirky atmosphere of the neighborhood with a heap of southern charm that has already won over customers in its infancy.

Crescent Hill is a historical district that could nourish a place like Eggs Over Frankfort. Ewing Avenue, the St. Matthews city limits, Brownsboro Road and Lexington Road roughly bind this 130-year-old neighborhood in east Louisville. Trains and streetcars that crossed through the area were vital in the development of the region as a residential and commercial area, according to the *Courier-Journal*. The main hub for Crescent Hill's businesses is Frankfort Avenue. Boutiques, bookstores, restaurants and secondhand stores line this busy street and make the area an appealing place to spend an afternoon. And Eggs Over Frankfort has settled into the scenery of this bustling street.

Eggs Over Frankfort has a curated charm that is down-home enough to comfort visitors while blending in with its offbeat neighborhood. The powder-blue walls are decorated with slivers of spare wood that are nailed to the wall like primitive wainscoting. Distressed windowpanes hang on the wall, which helps add a little whimsy since the only windows are in the front of this narrow building. There's a bookcase of mismatched mugs near the register for the coffee that co-owner Jackson Nave doles out to customers at the counter. My mug says, "Hire the left handed. It's fun to watch them write," accompanied by a sketch of a struggling southpaw.

With the limited hours, long lines and scant seating, it's a blessing to plunk down at the L-shaped counter near the back. An abandoned *Courier-Journal*

is left on the counter for future visitors, an important relic in the brotherhood of counter surfers. Space is tight in this restaurant, but the close quarters help reinforce that diner community feel. You can't help but make a friend when you're knocking elbows with the patrons on either side of you.

There are dishes with avocado and sprouts and other things that will look good when you track your calories in MyFitnessPal, but Eggs Over Frankfort's heartier fare is worth a try. There are whole-wheat pancakes ($8) and a stack that includes brown sugar candied bacon ($9) when you want to throw calories to the wind. There's a conventional cheeseburger with garlic aioli ($8) and a breakfast burger with goat cheese that comes on a maple-glazed English muffin ($10) when you want to indulge.

The menu is a little more pristine than other diners, but the old familiars are there. Even the Country Benedict, my favorite dish, is really just putting together what many of us have combined on our own plates—a warm, buttery biscuit topped with eggs, bacon or sausage and a generous pour of country gravy. The gravy here is thinner than what I've had at other diners (more of a sauce than a gelatinous glop), but it's full of flavor, thanks to the welcome bits of visible sausage. This savory dish is the perfect way to treat yourself, as long as you don't make eating this much meat and gravy a habit.

Jackson, who co-owns the restaurant with his wife, Cortney Nave, estimates that 150 people came to Eggs Over Frankfort's opening day, as *Business First* reported in 2014. Judging by those first-day numbers and my own crowded first visit, Crescent Hill residents and visitors were hungry for down-home diner food to go with their weekend shopping.

HIGHLAND MORNING

1416 Bardstown Road
Louisville, Kentucky 40204
502-365-3900
Facebook: https://www.facebook.com/HighlandMorning
Instagram User Name: highlandmorning
Twitter: https://twitter.com/highlandmorning

You're bound to spot at least one "Keep Louisville Weird" bumper sticker during a drive around the city. The Highlands is where this motto comes to life.

The Highlands filled me with awe as a South End kid. I was used to suburban streets lined with indistinguishable ranch-style homes. A car was vital to really get anywhere because no major retailers were within walking distance. The Highlands was the antithesis of everything I knew. Pedestrians popped in and out of boutiques, bookstores and coffee shops that were walking distance from their quirky apartments and ornate homes. From the passenger seat of my mom's Saturn, I'd gawk at the people perusing this vibrant district—older hippies, younger hipsters, families, friends, babies and plenty of dogs. The Highlands was where the cool kids and even cooler adults hung out.

A decade later, the Highlands is still one of the most eclectic areas of Louisville. The area is probably one of the few places in the state where you can smoke a hookah, buy a vintage dress and trade in your old comic books within a one-block span. Residents and visitors expect originality in the businesses and people who call this area home. And buying local isn't just a notion in the Highlands—it's a way of life.

The Highlands consists of several neighborhoods and commercial properties that surround a roughly three-mile corridor of Bardstown Road. It begins near downtown Louisville and runs south to the Watterson Expressway. The original Highlands started at East Broadway, and the community radiated out beginning in the early twentieth century. One of the first commercial districts sprang up around Douglass Loop at Douglass Boulevard and Bardstown Road. This was the location where a streetcar would make a "loop," which gave the area its name, according to a 1989 article in the *Courier-Journal*. During and after the Great Flood of 1937, Louisville residents and industries evacuated flood-prone areas near the Ohio River and began to settle in areas on higher ground, including the aptly named Highlands.

Highland Morning is a diner that feels right at home in this quirky neighborhood, a testament to how easily diners fit in just about anywhere they sprout. Like other diners, Highland Morning displays vigorous pride in its neighborhood. The restaurant celebrates Louisville's heritage with black-and-white photos of famous Louisvillians that hang above the tables. There are the usual suspects whose faces are already plastered around the city, such as newscaster Diane Sawyer and writer Hunter S. Thompson. But there are lesser-known folks with big pictures, too, such as National Football League player Lenny Lyles, musician Tim Krekel and actor Warren Oats. It's hard not to feel a little city pride when so many successful residents and natives are watching you eat. Even the sandwich selection calls on Louisville pride, with

A corner in the Highlands of Louisville. *Photo by Kelly Grether.*

neighborhood names such as Tyler Park's Egg Salad Sandwich ($7.00), the Bardstown Roadie ($8.00) and the Cherokee Triangle Club ($7.50).

There is a little more gleam and polish in Highland Morning than at the diner's more working-class counterparts. The location, which shares a building with two other businesses, feels a bit more cosmopolitan than freestanding diners. Large windows overlook the busy foot traffic outside, a result of Highland Morning's location near the busy intersection of Bardstown Road and Eastern Parkway. In the dining area, black tablecloths and a thick transparent topper cover each table. The service, however, is nothing but down-home. An attentive yet laidback staff is happy to make recommendations and chat.

As the name suggests, Highland Morning highlights the best in breakfast fare. The selections are surprisingly traditional and southern, such as grits ($2.00 to $3.00), biscuits and gravy ($3.50 to $4.50) and the southern pecan waffles ($7.50). There's plenty of inclusion of popular additions to the diner breakfast lineup, such as Nutella (between the layers of Katie's Leaning Tower of Waffles, $8.00) and a blueberry compote ($1.00) that customers can add to waffles or pancakes.

It's hard to order anything besides the Baja Benedict ($8.50) at Highland Morning. Not only is it listed on the menu as a Highland Morning Favorite, but the menu and waiter proudly proclaim that it's the most popular menu

item. The dish is a southwestern take on eggs Benedict. Instead of English muffins, two corn cakes flecked with green peppers provide the base. The cakes are brown and crisp on the top and bottom, which supports the spicy, crumbled chorizo on top. Then come the egg (poached medium is standard, but you can get the egg however you like), some crema and a handful of pico de gallo. At the waiter's suggestion, I subbed the grits for breakfast potatoes that soaked up some of the chipotle hollandaise sauce. The corn cakes are the best part of the dish.

Highland Morning is an important addition to the "Keep Louisville Weird" scene. Strip away the tablecloths and remove the view of bustling Bardstown Road, and you have a plain ol' diner where the cool kids hang out.

SHADY LANE CAFÉ

4806 Brownsboro Road
Louisville, Kentucky 40207
502-893-5118

The origin story of Shady Lane Café sounds like the setup for a quirky sitcom. A poet and a folk singer open a diner in one of the most posh neighborhoods in Louisville. Add a laugh track and a kooky neighbor, and you've got a hit network comedy.

The subsequent success of Shady Lane owners Bill and Susi Smith eclipses the restaurant's interesting story. For ten years, this married couple has served a charming take on diners to the East End. The Smiths' creative lives inject fun and whimsy into the food and service they provide in Shady Lane Café. Susi's infectious spirit greets customers, while Bill delights them with refreshing versions of classic recipes.

Shady Lane Café occupies a narrow space at the corner of the Brownsboro Center off Brownsboro Road in east Louisville. The shopping center dates back to the baby boom years and early suburban sprawl out of the core of Louisville, according to *Leo Weekly*. Shady Lane Café is a unique dining outpost in a neighborhood more akin to niche boutiques, chain restaurants, higher-end dining and expensive homes.

Shady Lane's sliver of the shopping center is perfect for the Smiths. The décor is as joyful as the Smiths. Tables and shelves are dotted with the couple's collection of salt and pepper shakers, many of which come from

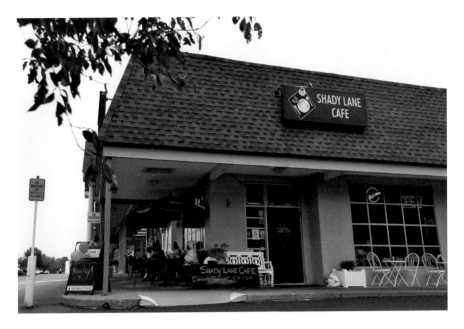

Shady Lane Café in Louisville. *Photo by Jessica Ebelhar.*

customers. There's a string of hamburger and hot dog Christmas lights. Knitted flowers hang from a potted plant. The room feels slightly disheveled, but the overall effect makes me feel at home. The personality of this space reflects the owners and the food.

Susi's is the first voice you'll hear when you enter Shady Lane Café. She is the woman behind the register, usually wearing colorful earrings and a big smile. If it's your first visit, Susi will guide you through most of Shady Lane's menu when you make it to the counter. Susi will always take that time to help her customers, even in the throes of the lunch rush. "If they're in front of me, I'll give them that moment," she says.

To new customers, Susi brags about Shady Lane's sandwich-heavy menu. She points to a wall covered in framed clippings from local newspapers and magazines to back up her glowing reviews of Bill's food. She's also quick to point out the rich desserts that she and Bill have baked. An array of pies and cakes taunts patrons from beneath their glass covers. Susi's encouragement makes you consider taking on a larger-than-average lunch topped with a sinful dessert. "I really like people, and I really believe in what we have," Susi says. "And that's the best combo."

While Susi mans the register, Bill works with his back to the patrons at the small griddle behind the counter. He'd been in the restaurant business

Customers enjoy lunch at Shady Lane Café. *Photo by Jessica Ebelhar.*

Salt and pepper shakers adorn the walls at Shady Lane Café. *Photo by Jessica Ebelhar.*

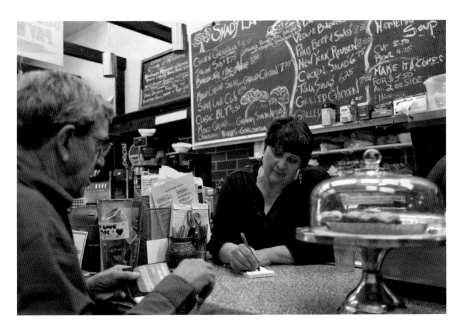

Susi Smith (right) takes an order from a customer at Shady Lane Café. *Photo by Jessica Ebelhar.*

before he left the industry to pursue a writing and academic career. Under the name W. Loran Smith, Bill published two collections of poetry, *Night Train* and *Walking Upright,* and was named "Best Poet" by *Louisville Magazine* in 2005, according to food critic Robin Garr's website, Louisville Hot Bytes.

But Bill had a hard time finding a teaching position at a university, he says, so he came back to restaurants. He wanted to make familiar, handmade dishes that would be accessible to a wide audience. "That's what I'm trying to do—good, simple food," he says.

Quality draws many folks to Shady Lane. *Louisville Magazine* selected the Brownsboro Burger ($6.50) as the city's best burger. In theory, there's not much to this sandwich. It's just a hamburger. But it's a burger done right—quality ground beef cooked and dressed to order. The Brownsboro Burger proves that simplicity can overpower the fanciest of flavors. I'm also a fan of the meatloaf sandwich. Slices of house-made meatloaf are seared and placed on a bun. It's a far cry from a cold meatloaf sandwich you eat over the sink at midnight. Bill's meatloaf is well seasoned and rich. It's served with a side of Henry Bain sauce, a barbecue sauce–like condiment with Louisville origins, but it's barely needed on such juicy pieces of meat.

Shady Lane keeps its prices low, especially in comparison to its surroundings. Sandwiches, which make up the largest portion of the

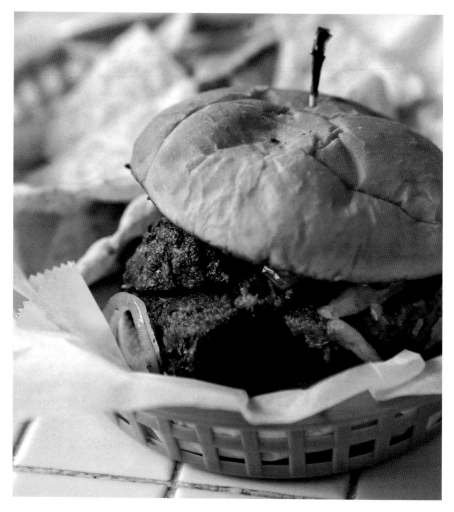

The meatloaf sandwich with tortilla chips at Shady Lane Café. *Photo by Jessica Ebelhar.*

menu, range from $6.50 to $8.50 and come with tortilla chips. Side dishes, such as the smoked bacon potato salad, home-fried potato chips and crinkle-cut fries, are an additional $2.00. The affordability brings a diverse audience through Shady Lane's doors. "We have zillionaires sitting next to construction workers," Bill says.

Their unique brand of hospitality brings in so many customers that the line extends to the door on most afternoons. "It's almost like a battle when you have a line through the door," Bill says. "Every day is sort of winning that battle and seeing the smiles on people's faces."

Pat King (standing) chats with her granddaughter Katie Devore after they place their orders at Shady Lane Café. *Photo by Jessica Ebelhar.*

Bill and Susi's attentiveness also leaves an imprint on the lives of the people they serve. Customers have asked Susi to sing at weddings and funerals. The couple just put up a plaque to mark the table of Ed Richter, a regular who passed away in 2014 at age ninety-four. The Smiths have watched kids grow up and eventually bring in their own kids. "I feel very proud that we're able to have this connection with the customers," Susi says.

Shady Lane Café takes up a large chunk of Bill and Susi's lives. The duo makes sure to make time for their other passions. Bill wakes up at 3:00 or 4:00 a.m. to write poetry for a few hours before restaurant work begins. Susi still performs at events in the area, and she'll pull out a guitar and sing in Shady Lane when things get slow.

Susi Smith, who co-owns Shady Lane Café with her husband, Bill, takes a break to sing "Me and Bobby McGee" during lunch service. *Photo by Jessica Ebelhar.*

Ten years have taught the couple how to efficiently work together. "It's something that evolved," Susi says. "We have a very good relationship, and that makes a difference."

Bill is the quieter of the two as he focuses on the work in front of him. Susi is the main point of contact for the customers. Clear communication is key in getting the right orders in and out to eager patrons. Together, the Smiths have an easygoing rhythm with each other, even though they share a space that is comparable to a modest galley kitchen. I ask what their secret is to getting along when you share such close quarters with your spouse. "Maybe it's because we both face different directions most of the day," Susi says.

SuperChef's Breakfast and More

307 Wallace Avenue
Louisville, Kentucky 40207
502-896-8008
http://www.fromsimple2super.com
http://www.mysuperchefs.com
Twitter: https://twitter.com/SCBreakfastKy

"Have you been to that one breakfast place inside the consignment shop?" Miss Barbara, a longtime customer at my parents' hair salon, loves eating out as much as I do. We exchange stories of recent trips we've made to restaurants around Louisville. I try to stay ahead of the curve, but I had no idea what Miss Barbara was talking about. A restaurant? Inside a consignment shop? I thought. How does that work?

Very well, actually. SuperChef's Breakfast and More takes up the back half of the Ruby Slipper, a tiny consignment shop on Wallace Avenue in the St. Matthews neighborhood. Don't let the diner's modest accommodations fool you. This unconventional location in the East End is a suitable setting for the originality that the restaurant offers in its progressive breakfast and lunch menus.

Faith, gumption and creativity have made SuperChef's a notable addition to Louisville's diner scene. Owners Darnell Ferguson and Rodney White tackle familiar dishes with youthful ingenuity and confidence. Their food is as unexpected and nontraditional as their location. And these men are serious about their business and their craft. "We're very confident in what we do," Rodney says. "And we're prayed up on it."

For the past two years, Darnell and Rodney have rented out space from businesses that are closed during breakfast hours. Their first Louisville location was in Chicago Gyros on Brownsboro Road. The men operated SuperChef's during the morning and closed in time for Chicago Gyros to start serving at 11:00 a.m. After Chicago Gyros closed, they moved SuperChef's into the back of the Ruby Slipper in 2013 in a space that was previously Bloom's Lunch Café, according to the website StyleBlueprint Louisville. For a while, SuperChef's would serve breakfast out of the now-closed restaurant called the Seafood Connection in Chenoweth Square in St. Matthews and then head to the Ruby Slipper for lunch. Sharing space has been risky, especially when the flagstone operation closes abruptly, as

was the case with the Seafood Connection. But overall, these dual-use spaces have been valuable to the early success of SuperChef's. They've eliminated many frustrations familiar to first-time restaurateurs, such as spending money on décor or furniture or kitchen equipment. Sharing space with an existing business also gave them access to an established client base. For example, Chicago Gyros customers might have come in for a sandwich in the evening, but they would return to visit SuperChef's in the morning after they learned about the partnership, Rodney says.

SuperChef's unique setup enhances this restaurant's appeal as a hidden gem in Louisville. The location makes getting to SuperChef's an adventure for first-time visitors. Add a delicious meal, and it's hard not to brag to everyone you know about the cute place you found *in a consignment store.* Darnell and Rodney rely on this word of mouth to bring in new customers. They also depend on the allegiance of regulars who have followed them from location to location.

A creaky screen door welcomes customers into the Ruby Slipper, a shop that's as small as the living room of my one-bedroom apartment. There's a wealth of costume jewelry, autumn décor and no fewer than four posters of Marilyn Monroe among the array of tchotchkes for sale.

A doorway at the end of the room opens to the SuperChef's humble dining area. There's enough room for nine tables and a couple more in a partitioned section in the back. Flickering fluorescents light the windowless space. A swinging red door, the kind you see in old western movies, separates the kitchen from the dining room, but not by much. I catch plenty of conversation about the new Matthew McConaughey movie.

Weekday mornings are pretty quiet at SuperChef's. There are only two other tables of customers, so Rodney handles the dining room solo. Early 2000s R&B plays over the speakers, and the TV's on mute, which makes for a pretty calming atmosphere to begin the day.

It's hard to decide where to start with the SuperChef's menu. Darnell and Rodney want to do things with breakfast that no one else has done. Classic dishes are available but are easy to overlook in favor of the more decadent selections. Who would want a normal waffle when you can get root beer float waffles ($10.99) topped with French vanilla ice cream and root beer–infused syrup? Sure, there's a veggie omelet ($6.99) and a sausage and cheese omelet ($7.50), but why not try the Hunger Games omelet ($11.99) made with egg whites, barbecue pulled pork, caramelized onions and cheese? And the Super Duper Cakes are over the top, with

choices like the Liu Kang, with hot chocolate–flavored pancakes with chocolate mousse and cream cheese ($11.99), or the Raiden ($11.99), made up of one vanilla, one strawberry and one chocolate pancake.

I enjoy SuperChef's take on French toast ($7.99). Darnell coats bread with pieces of granola before he fries it. The addition gives the bread a crisp crust that goes well with the drizzle of syrup and strawberry compote that tops the dish. The two pieces of toast don't need any extra syrup—the granola adds enough sweetness to the dish. Even something as simple as a bacon, egg and cheese sandwich ($8.50) gets an upgrade at SuperChef's. The bacon is candied and provides a sweet companion to the savory egg and cheese. Instead of plain bread, the sandwich comes on a toasted pretzel croissant.

At twenty-seven and twenty-six, respectively, Darnell and Rodney are young enough to still have a post-collegiate optimism about making it in the restaurant industry, but they have enough experience and skills to back up their confidence. Both attended Sullivan University, a college in Louisville with culinary arts and hospitality programs. Darnell was a chef for Team USA at the 2008 Beijing Olympics, where the nickname "SuperChef" began to stick, according the SuperChef's website. With partner Ryan Bryson, they've also opened two SuperChef's operations in Darnell's home state of Ohio. And Darnell cohosted a cooking segment on local TV station WHAS11 called *From Simple to Super.* So Darnell and Rodney are ready to take on the competitive restaurant industry of Louisville.

"We realize we have a lot of potential," Rodney says. "We're more excited than intimidated."

Soon, SuperChef's might step from behind the secondhand merchandise. Darnell and Rodney have their eyes on a freestanding building for sale on Brownsboro Road. If everything works out, the restaurant will stretch its legs into dinner with an evening small plate menu. "Once we get our own restaurant," Rodney says, "we won't be a secret."

WILD EGGS

Louisville locations include:

121 South Floyd Street
Louisville, Kentucky 40202
502-690-5925

3985 Dutchmans Lane
Louisville, Kentucky 40207
502-893-8005

1311 Herr Lane
Louisville, Kentucky 40222
502-618-2866

153 English Station Road
Louisville, Kentucky 40245
502-618-3449

http://www.wildeggs.com
Facebook: https://www.facebook.com/WildEggsKentucky, https://www.facebook.com/WildEggsColorado
Twitter: https://twitter.com/WildEggsBGKY, https://twitter.com/wildeggsco

Let me begin this section with a disclosure to explain any bias that follows: I eat at Wild Eggs. A lot. An embarrassing amount, actually. Location is partly responsible for my reliance on this modern diner for breakfast and brunch. I live within walking distance of one of Wild Eggs' four Louisville locations. Proximity is important on lazy weekend mornings that call for big cups of coffee and sweatpants.

However, Wild Eggs is much more than just a convenient location. The diner excels because of its adventurous menu, bright atmosphere, moderate prices and consistent quality and service, especially as the restaurant expands across the state and country. Plus, Wild Eggs is just plain good.

Wild Eggs was one of the first restaurants in Louisville to introduce a modern diner concept when it opened in 2007. At its core, Wild Eggs has the features and food of a traditional diner. Yet the restaurant elevates the genre by focusing on a "chef-driven" menu, modern presentation and rigorous

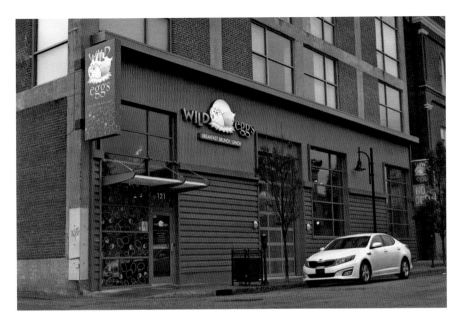

Wild Eggs in downtown Louisville. *Photo by Jessica Ebelhar.*

Executive chef Trevor Semones prepares meals at Wild Eggs. *Photo by Jessica Ebelhar.*

staff training to enhance the customer experience, says J.D. Rothberg, one of the Wild Eggs' owners.

J.D. and his business partner, Shane Hall, began to develop the Wild Eggs concept in 2005. J.D., who has a background in corporate restaurant work,

Chris Enochs prepares a dish at Wild Eggs. *Photo by Jessica Ebelhar.*

says that the duo spent time traveling across the country to research diners and other restaurants that served breakfast. "We knew we wanted to do breakfast, and we wanted to be different," J.D. says. "We just saw a real need for it [in Louisville]. There's breakfast out there, but there's nothing unique."

They decided to focus on eggs, the centerpiece of early-morning meals. "There's really nothing more classic about breakfast than eggs," J.D. says.

You can get an egg just about any way you can imagine it at Wild Eggs. But plain eggs just wouldn't do for J.D. and Shane. The "Wild Eggs" portion of the restaurant's menu is where the chefs show off their creativity. The restaurant takes dishes you wouldn't normally associate with breakfast and combines them with the ever-present egg for surprisingly delicious meals. There's also a heavy Mexican influence on the menu, which happened by accident, J.D. says. Ingredients typical to Mexican cuisine, such as salsa and peppers, happen to go well with eggs. The Breakfast Nachos are the perfect example of this restaurant's outlook on eggs and the ingenuity of its chefs. The dish has everything you'd expect from nachos—tortilla chips, refried beans, sour cream, pico de gallo, jalapeños, guacamole and green onions. But Wild Eggs tops this pile with chipotle queso hollandaise sauce and two eggs cooked any way you like them.

Wild Eggs has fun with other well-known dishes. The Kelsey "KY" Brown is an updated take on the Louisville-born Hot Brown. Wild Eggs'

Kalamity Katie's Border Benedict at Wild Eggs. *Photo by Jessica Ebelhar.*

version adds a fried egg to the classic Hot Brown components of bread, turkey, bacon, diced tomatoes and Mornay sauce. And there are five types of eggs Benedict—traditional, vegetarian, mushroom, smoked salmon and the Kalamity Katie, a creation made of green chili cheddar corn cakes, chorizo, two poached eggs, queso fundido, pico de gallo, sour cream, green onions and avocado.

There are still plenty of classic staples on the Wild Eggs menu. Customers appreciate the option to get adventurous or stay in their comfort zone, J.D. says. The most popular dishes—the Kalamity Kate and the build-your-own omelet—reveal the dual mindset of patrons. "Really, at the end of the day, people are waiting for bacon and eggs," J.D. says.

I'm one of those people happy with a more simple breakfast from Wild Eggs. My favorite order is the "Zax I Am Fried Eggs and…," an oddly named dish that comes with two eggs any style, skillet potatoes and a savory "Everything" muffin. I usually add a side of bacon and replace the muffin with a pancake, a buttermilk creation that takes up an entire plate. It's simple, but it's a basic, pleasing meal with which to begin the day. "If you have the right flavors and good quality, our food is really pretty simple," J.D. says.

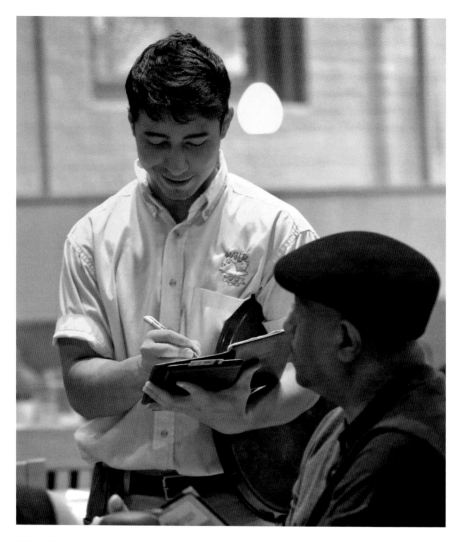

Miguel Verastegui takes an order at Wild Eggs. *Photo by Jessica Ebelhar.*

Whatever the flavors customers seek, plenty of them end up in Wild Eggs, especially on the weekend. The wait at my location of choice is usually at least twenty minutes on a late Sunday morning. Other than tiny, complimentary cups of coffee and a few copies of the menu, there's not much to keep yourself entertained as you wait. But it's rare to see people turn away from the restaurant because of the line for a table. Patrons know that at the end of their wait, Wild Eggs will serve a meal that exceeds expectations.

Bright colors and minimal design create a cheerful atmosphere at Wild Eggs. *Photo by Jessica Ebelhar.*

If the free coffee isn't enough to keep you awake, the décor should do the trick. The inside of every Wild Eggs is as colorful as the food. Wild Eggs borrows elements from classic diners and adds a splash of color and modern design. Sleek, space-age chrome features punctuate the Wild Eggs dining room. The diner counter has been updated to a circular bar. The color palette is heavy on pastels, bringing to mind an appropriate comparison to Easter eggs. Other than a few large photographs that feature eggs, the decorations are minimal. Wild Eggs tips its hat to its diner originators while giving customers interior design that complements their meals.

Wild Eggs' modern dining rooms have begun to multiply. There are now four locations in Louisville; one in Lexington, Kentucky; and another in Bowling Green, Kentucky. There's even a Wild Eggs in Denver, Colorado, where J.D. grew up. The company wants to open six to eight corporate and franchise Wild Eggs locations.

I always worry about quality when restaurants I like begin to blossom into small chain operations. Consistency is a virtue when a restaurant begins to open multiple storefronts. Ideally, a customer will have an identical experience no matter which location of the same restaurant they go to. Will Wild Eggs' food still be as good if there are multiple locations spread across the state and country? As a frequent patron, I hope the signs point to "yes."

Dishing with Emily Hagedorn

Louisville Community Manager, Yelp

Users are integral to the review website Yelp. Emily Hagedorn builds the Louisville Yelp community by interacting with reviewers, reaching out to businesses and hosting sponsored events to showcase local businesses. Even though shopping is the most popular category on the website, Yelp gets much of its attention from the restaurant reviews that users post. Emily and I discussed diners in the age of social media, Yelp reviewers and some of her favorite diner food.

Ashlee: *What do you like most about the Louisville dining scene?*
Emily: I think that there are a lot of people willing to take chances in doing one-of-a-kind things. It's always exciting when a new place opens because chances are, it's something that you haven't had or haven't had in a long time. It seems like a lot of the restaurants that go in are trying to find a niche. They definitely go in with an idea of who they are and what they're going to do, they've done the research and [they're] going into fun areas. I feel like a lot of the restaurants that succeed have their niche, and they stick with it.

Ashlee: *Are people hesitant to go off the main restaurant strips, such as Bardstown Road and Frankfort Avenue, to visit restaurants?*
Emily: Yes and no. I feel like everyone has their neighborhood, whether it's where they live or work or that they're big fans of because they're there a lot…We wrapped our arms around the places we knew best, like the Highlands and Frankfort Avenue and all those places, and now we have those places figured out. And we see what happened with places like NuLu and how one day it wasn't here and one day it was, and that was great. Now we're kind of looking at other places…

I think there's a little bit of an exploration going on. I think Yelp helps with that. I said earlier that I thought I knew all the restaurants, but I knew all the restaurants in my neighborhood, and that was my worldview. I was like, "This is it. These are all the restaurants that are out there." Since I've found more restaurants, I've definitely made more trips to go to little places.

Ashlee: *How do you define a diner?*
Emily: When I think of a diner, I think of the 1950s style with the linoleum countertops, swivel chairs at the counter, booths and tables, breakfast or

brunch. I don't know if you call that brunch at a diner or just breakfast. But [a diner has] a good array of hamburgers and clubs and sandwiches and that type of thing.

Ashlee: *Do you find that Yelp reviewers contribute a lot of reviews to small restaurants such as diners?*
Emily: Yes and no. Definitely the locally owned restaurants are the big things to review on Yelp. I feel like the trendy restaurants get a lot of reviews. Once a group kind of discovers it, it kind of becomes a snowball effect…I feel like discovering those diners is a lot of what I like about Yelp because I found out about a bunch of them because of [the website]. That's a reason why people will use it—not just to write reviews, which is great, but also looking out to see what people are writing about. Because when you find that really cool restaurant you didn't know about and you've been here for years, it's kind of a neat moment.

Ashlee: *What are some things that Yelp has taught you about smaller restaurants in Louisville?*
Emily: The food is simple, but a good, simple dish done well can make a huge impact. A lot of restaurants nowadays in Louisville, since we're becoming this foodie place, are all about doing something different and fancy. It's not only rice; it's quinoa. It's just bigger and better. But with diners, the simpler you can get it, that's what people want, and that can go a really long way.

Ashlee: *Why are diners and other small restaurants important to the city?*
Emily: The whole "Keep Louisville Weird" mantra. It's all about being original, and original is in the eye of the beholder…And also, Louisville loves its local businesses, and diners are the quintessential local business.

CLOSING

I thought people liked diners just for the nostalgia. Then I started writing this book.

I've visited all kinds of Louisville diners—the more upscale and modern, the true holes-in-the-wall and a lot that fall somewhere in between. We project our own memories onto the comfort food we find waiting for us. The college kids at Burger Boy reminded me of my own late-night food runs with friends. The meatloaf at Shirley Mae's Café and Bar took me back to the meals of my adolescence. Then I visited Shady Lane Café. The kindness of Bill and Susi Smith made me feel warm and fuzzy before I even took a bite of my burger. I had no memories to attach to this restaurant, yet I felt like I was right at home.

That's when I realized that it wasn't just nostalgia that made me happy when I walked out of so many diner doors. Each of these businesses gave me room to enjoy my meal and my memories however I chose. From old favorites to new establishments, Louisville's diners provide welcoming environments to anyone who needs one. Diners embrace each of us no matter the background or profession or any other quality that we deem important. Owners, servers and cooks deliver genuine hospitality without any fancy gimmicks, and they expect the same from us—no attitudes, no fronts, just gratitude for a decent meal. In diners, we can just be ourselves.

For more than one hundred years, diners have given us what we needed before we even knew we needed it. Maybe it's a meal to remind us of home

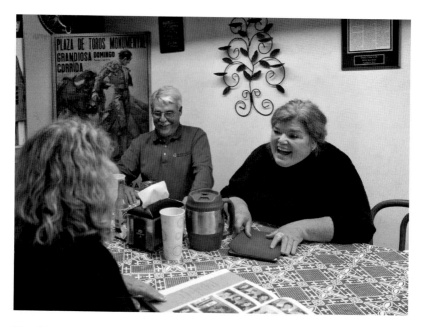

Fran Kincheloe (bottom left), Bob Detherage (center) and Cindy Hensley (right) look through yearbooks at Shady Lane Café. The trio graduated from Ballard High School in 1972, the same year as diner co-owner Bill Smith. *Photo by Jessica Ebelhar.*

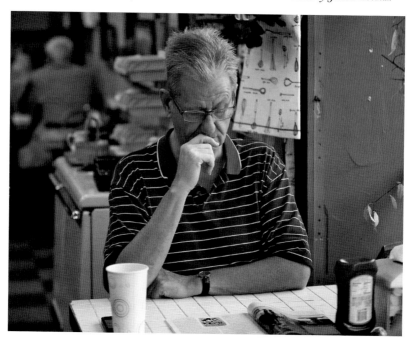

Customer Bruce Kleinschmidt reads a magazine at Shady Lane Café. *Photo by Jessica Ebelhar.*

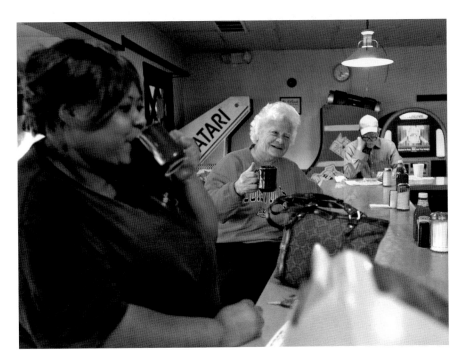

Marilynn Bruner (center) enjoys a cup of coffee at Barbara Lee's Kitchen. *Photo by Jessica Ebelhar.*

when we live so far away. Maybe it's a lot of food for less than ten dollars because that's all we can spare right now. Whatever the reason for our visit, we can go to diners just as we are. And sometimes, if we're lucky, we leave a diner just a little bit happier. That's good enough for me.

TIPS FOR YOUR NEXT DINER VISIT

Plan on stopping by a Louisville diner? Here are some things to remember so you can get most out of your experience.

- *Carry cash.* Many diners profiled in this book skip card machines and apps and prefer to operate as cash-only businesses. Sometimes, there are ATMs in or near the diner, but bring at least ten dollars in cash to cover your meal and tip. And speaking of a tip…

- *Tip your server well.* Waiters and waitresses are the folks who keep a diner running. At the smallest mom and pops, the person bringing you your meal might even be the owner. Servers are some of the most hardworking people in this city, so treat them accordingly.

- *You'll probably need to seat yourself.* Most diners don't have a hostess stand. Pick your own table or seat if you don't see an employee milling around near the entrance.

- *Get close to the action.* I recommend a stool at the counter for the best view of the griddle. It's just as entertaining as a hibachi grill.

- *Be prepared for small talk.* I tend to be a pretty quiet customer when I haven't had my coffee. That doesn't work in a diner. The places I've

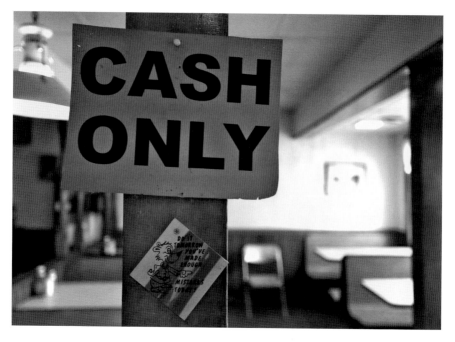

The interior of Barbara Lee's Kitchen. *Photo by Jessica Ebelhar.*

visited are full of conversation at tables, between tables and from the table to the kitchen. Relax and meet someone new.

- *Press pause on your healthy eating plans.* Diners are not the place to hold back from ordering a patty melt or chili cheese fries. Give yourself a pass on your diet and get back on plan during your next meal. However…

- *It's possible to eat healthy at a diner.* There are veggie burgers and grilled chicken, oatmeal and whole wheat pancakes, egg whites and even egg substitutes. It's not impossible to eat right. It's just so tempting not to.

BIBLIOGRAPHY

Anderson, Will. *Where Have You Gone, Starlight Cafe? America's Golden Era Roadside Restaurants.* Portland, ME: Anderson & Sons' Publishing, 1998.

Barry, Jack. "Douglass Loop: Landscape of Landmarks." *Courier-Journal*, February 16, 2007. http://archive.courier-journal.com/article/99999999/ZONE01/70131032/Douglass-Loop-Landscape-landmarks.

Beckner, Sean. "The Real Reason Millennials Go Out to Eat." *Fast Casual* (July 11, 2013). http://www.fastcasual.com/articles/the-real-reason-millennials-go-out-to-eat.

Bowling, Caitlin. "First Day 'Better than We Expected,' Eggs Over Frankfort Co-Owner Says." *Business First of Louisville* (June 16, 2014). http://www.bizjournals.com/louisville/news/2014/06/16/first-day-better-than-we-expected-eggs-over.html.

Carman, Tim. "For Millennials, Food Isn't Just Food. It's Community." *Washington Post*, October 22, 2013. http://www.washingtonpost.com/lifestyle/food/for-millennials-food-isnt-just-food-its-community/2013/10/22/b6068902-35f2-11e3-8a0e-4e2cf80831fc_story.html.

Chaplin, Steve. "Jessie's Marks 25 Years of Serving Good Food on Dixie Highway." *Courier-Journal*, March 3, 1999.

Cocanougher, Kelly. "Fare Increase…Ollie's Trolleys Plans to Broaden Menu and to Add Seats." *Louisville Times*, November 1, 1974.

Edelen, Sheryl. "Friends Cook Up Honor for Dizzy Whizz Owner." *Courier-Journal*, May 24, 2000.

Elson, Martha. "Crescent Hill: Ridge's Contour Gave Rise to Name." *Courier-Journal*, February 16, 2007. http://archive.courier-journal.com/article/99999999/ZONE01/70131033/Crescent-Hill-Ridge-s-contour-gave-rise-name.

———. "Historic Wagner's Pharmacy Now Just 'Wagner's.'" *Courier-Journal*, May 16, 2014. http://www.courier-journal.com/story/communities/2014/05/16/wagner-pharmacy-churchill-breakfast-elson-prescriptions/9179477.

———. "1937 Flood Changed Louisville Forever." *Courier-Journal*, January 17, 2012. http://archive.courier-journal.com/article/20120118/ZONE07/301180045/1937-flood-changed-Louisville-forever.

Garr, Robin. "We Sing the Praises of Shady Lane Café." *Leo Weekly*, October 9, 2013. http://leoweekly.com/dining/we-sing-praises-shady-lane-café.

Gibson, Kevin. "The Taste Bud: Long Live the Ollie Burger." *Leo Weekly*, August 25, 2010. http://leoweekly.com/dining/taste-bud-long-live-ollie-burger.

Greene, Marvin. "Recipe for Success: Cafeteria Expansion Called Testament to Entrepreneurship." *Courier-Journal*, September 2, 1993.

Green, Maggie. *The Kentucky Fresh Cookbook*. Lexington: University Press of Kentucky, 2011.

Gutman, Richard J.S., Elliot Kaufman and David Slovic. *American Diner.* New York: Harper and Row, 1979.

Harris, Jessica B. *High on the Hog: A Culinary Journey from Africa to America*. New York: Bloomsbury, 2011.

Heimann, Jim. *Car Hops and Curb Service: A History of American Drive-In Restaurants, 1920–1960*. San Francisco, CA: Chronicle Books, 1996.

Hurley, Andrew. *Diners, Bowling Alleys, and Trailer Parks: Chasing the American Dream in the Postwar Consumer Culture*. New York: Basic, 2001.

Jeffries, Fran. "Good Cooking and Repeat Customers Feed Jay's." *Courier-Journal*, February 18, 1991.

Jones, Michael L. "Twig and Leaf: Fate Uncertain." *The Highlander*, February 26, 2011. http://www.thehighlanderonline.com/print-articles/features/396-twig-and-leaf-fate-uncertain.

Jones, Steve. "Kentucky Derby | Wagner's Pharmacy Has Ownership Connection." *Courier-Journal*, April 30, 2014. http://www.courier-journal.com/story/sports/horses/triple/derby/2014/04/30/kentucky-derby-wagners-pharmacy-ownership-connection/8516931.

Kleber, John E., ed. *The Encyclopedia of Louisville*. Lexington: University Press of Kentucky, 2001.

Lee, Eve. "CVS Developers Drop Twig and Leaf Plan; Diner May Be Protected [Highlands]." Louisville.com, August 17, 2010. http://www.louisville.com/content/cvs-developers-drop-twig-and-leaf-plan-diner-may-be-protected-highlands.

Lee, Eve, and Robin Garr. "Don't Think Twice—Highland Morning's All Right." *Leo Weekly*, April 20, 2011. http://leoweekly.com/dining.

Loosemore, Bailey. "Doors Open at Jessie's on Dixie." *Courier-Journal*, June 26, 2014. http://www.courier-journal.com/story/news/local/southwest/2014/06/26/doors-open-jessies/11397543.

Louisville Times. "Lum's Headquarters Will Move to Louisville." August 14, 1974.

National Register of Historic Places Registration Form. "Smoketown Historic District." U.S. Department of the Interior, National Park Service, July 3, 1997.

New York Times. "Oliver Gleichenhaus; Burger Maker, 79." January 14, 1991. http://www.nytimes.com/1991/01/14/obituaries/oliver-gleichenhaus-burger-maker-79.html.

Norman, Phil. "Ollie's Trolleys, Gathering Up Steam, May Be Following 'Chicken' Tracks." *Courier-Journal*, August 29, 1973.

O'Bryan, Danny. "After 38 Years, the Broadway Dizzy Whizz Becomes a Thing of the Past." *Courier-Journal*, May 5, 1986.

Opie, Frederick Douglass. *Hog and Hominy: Soul Food from Africa to America.* New York: Columbia University Press, 2008.

Pike, Bill. "Community Restaurant Endures; Dixie Highway Eatery to Mark 30th Birthday." *Courier-Journal*, February 13, 2004.

Potter, Heidi. "Who Is SuperChef?" *StyleBlueprint Louisville*, July 17, 2013. http://styleblueprint.com/louisville/everyday/who-is-superchef.

Preservation Louisville. "Advocacy." http://preservationlouisville.org/advocacy.html.

Rosen, Marty. "Franco's Restaurant and Catering | Louisville Restaurant Review." *Courier-Journal*, June 11, 2010. http://archive.courier-journal.com/article/20100612/SCENE02/6120323/Franco-s-Restaurant-Catering-Louisville-Restaurant-Review.

Runyon, Keith. "Old Louisville Area Listed in U.S. Historic Register." *Courier-Journal*, February 12, 1975.

Schneider, Grace. "Johnny Dollar's Goes Cadillac; Deli Owners' 50s-Style Grill Will Replace All-Night Diner." *Courier-Journal*, March 30, 1988.

Werbach, Adam. "The American Commuter Spends 38 Hours a Year Stuck in Traffic." *The Atlantic*, February 6, 2013. http://www.theatlantic.com/business/archive/2013/02/the-american-commuter-spends-38-hours-a-year-stuck-in-traffic/272905.

Werner, Larry. "New Homes, Rehabilitation Keys to Old Louisville Plan." *Courier-Journal*, September 26, 1969.

White, Charlie. "Kathy and Joe's Place Re-Creates Home-Cooked Flavors." *Courier-Journal*, April 18, 2012. http://www.courier-journal.com.

Wilson, Cynthia. "Jay's Cafeteria Serves Up Expansion Plans." *Courier-Journal*, February 5, 1992.

Witzel, Michael Karl. *The American Drive-In: History and Folklore of the Drive-In Restaurant in American Car Culture.* Osceola, MN: Motorbooks International, 1994.

INDEX

ABOUT THE AUTHOR

Ashlee Clark Thompson is a freelance writer and food blogger. She is the creator of AshleeEats.com, where she documents her search for good, cheap food in Louisville, Kentucky. Her work has appeared in *Food and Dining Magazine* and *Leo Weekly* and on WFPL.org.

When she's not writing, Ashlee watches way too much *Golden Girls*, dabbles in vegetarian cooking and pretends that she will have time to get back into knitting. Ashlee lives in Louisville with her husband, Robert, and their dog, Roscoe.

Photo by Jessica Ebelhar.